HOW TO
PHOTOGRAPH
PETS

Nick Ridley

GUILD OF
MASTER CRAFTSMAN
PUBLICATIONS

First published 2002 by
Guild of Master Craftsman Publications Ltd,
166 High Street, Lewes,
East Sussex, BN7 1XN

Photographs: Nick Ridley
Illustrations: John Yates

ISBN 1 86108 242 8

British Cataloguing in Publication Data
A catalogue record of this book is available from the British Library.

Designed by Francis & Partners
Typeface: Sabon and VAG Rounded

Colour separation by Viscan Graphics Pte Ltd (Singapore)
Printed and bound by Kyodo (Singapore) under the supervision of
MRM Graphics, Winslow, Buckinghamshire, UK

Dedication

Yet another of my many 'dreams and schemes' that would have never seen the light of day if it wasn't for the constant support of my wife Debbie and my two daughters Gemma and Holly. I am sorry for the many grumpy moments that you have all had to suffer over the past year.

And to Meg, an English springer spaniel who was my constant companion and 'best friend' for 12 short years. You are sadly missed.

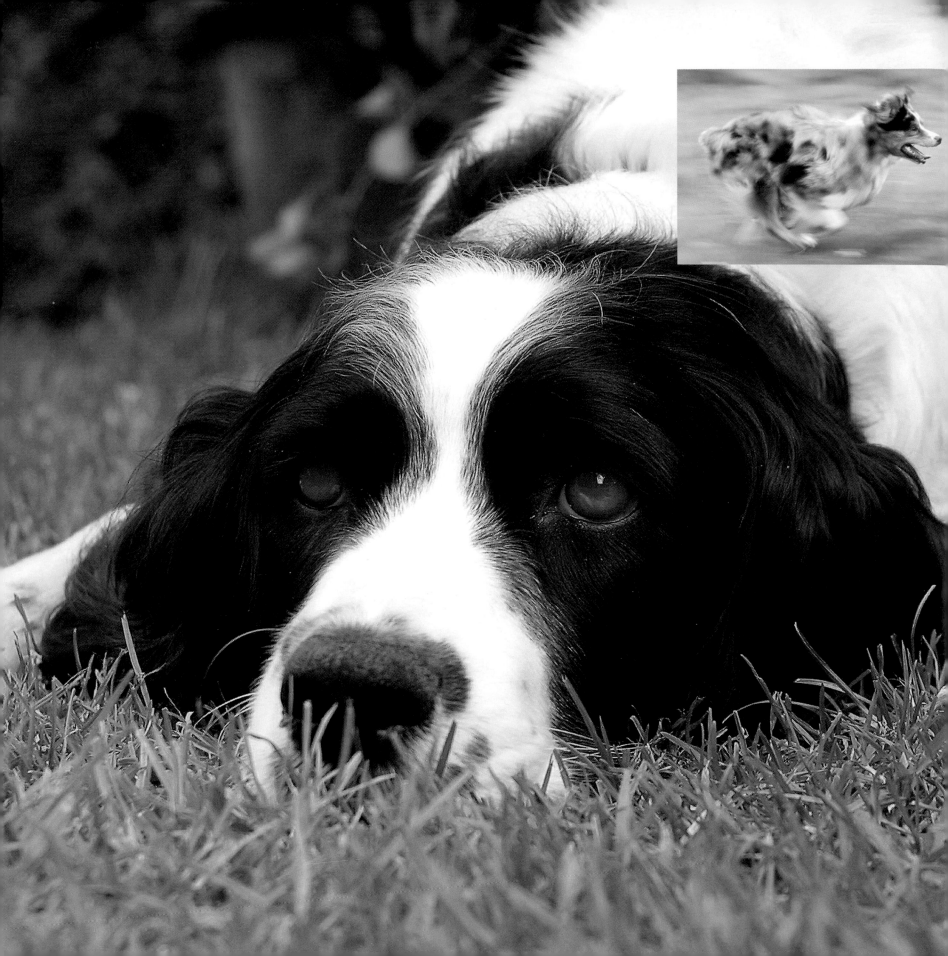

Contents

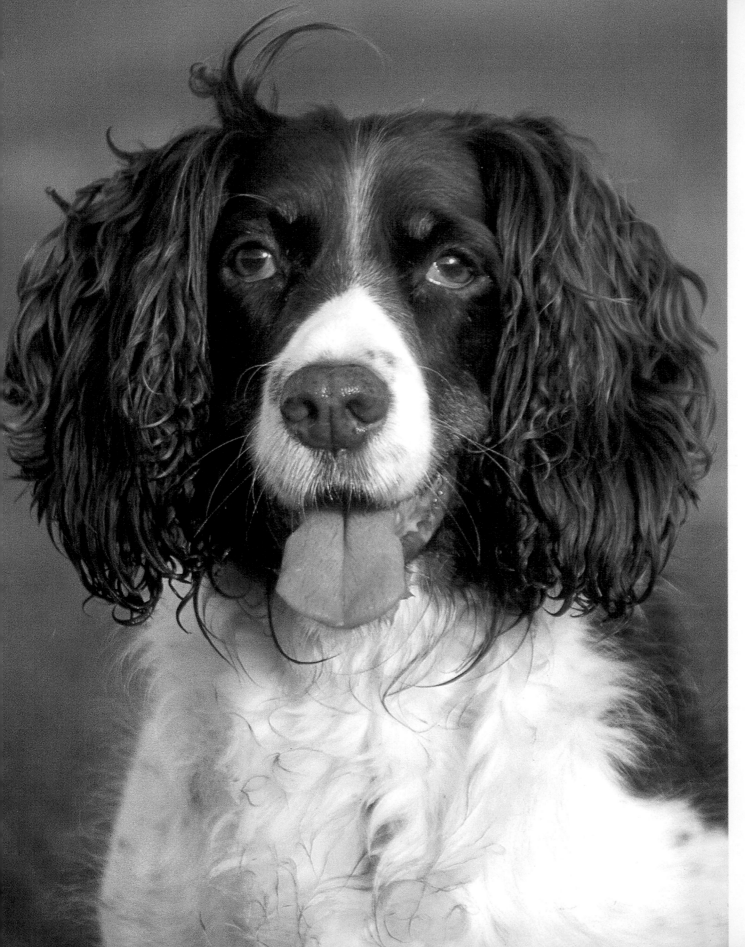

They say that the dog is man's best friend and for many people this is true. However, there are plenty of other pets that share our homes and are considered to be part of the family. With the popularity of photography growing at an incredible rate, more and more owners are striving to get that extra special photograph of their own 'best friend'.
English springer spaniel
Canon D30,
28–135mm lens

Introduction

It is estimated that there are more than 250 million pets sharing our homes in Europe and the USA, and that only accounts for cats and dogs. To most of us they are as important as the rest of our family and for some of us they are our family.

It will, no doubt, be noticed that many of the dogs featured in this book are gun-dog breeds; this is a consequence of living and working in a rural part of the country and no bias is intended although, in truth, I do have a passion for working-bred dogs. The cats presented a never-ending challenge and, as for the small furry creatures … let's just say that the Ridley household has increased in population by a factor of four.

We all like to photograph our pets and taking professional-looking portraits need not be as complicated as we are sometimes led to believe. Although it does require time and patience, it does not necessarily require bags of expensive equipment.

It helps if you know your subject and how to encourage the animal to relax and behave naturally in front of the camera.

Sessions should be kept short. Animals are like children and will soon get bored and, once that happens, it is time to put away the camera and wait for another day.

The art of any form of portrait photography is to capture the character and personality of the subject matter and, although you can't ask your pet to say 'cheese', there are ways and means to encourage a cocked head or a lazy swipe of a paw (see Bits and Bobs on page 16).

Whatever methods you use, be prepared to experiment and always remember the welfare and safety of the animal must come first – no photograph is worth harming or causing stress to your pet.

Good photographers have the ability to 'see' a picture and then put the elements in place to achieve the desired effect. The overall aim of this book is to give you, as a pet owner, the inspiration and knowledge to take stunning photographs of your pet, however inexperienced you may be as a photographer.

Chapter 1

Photographic Equipment

Take a look in any high street photography shop and you are likely to become totally confused by the multitude of cameras and equipment on sale. Large and medium format, SLRs, APS, digital, zoom, telephoto, macro – these are all terms that experienced photographers use in their daily dialogue. But, for the purpose of achieving that special picture of your pet, we can dispense with much of the jargon and concentrate on three main formats – the 35mm SLR, APS compact and the digital zoom camera. To create something special, you will also need a few extras tucked away in your camera bag, such as a flashgun, a bought or home-made reflector and that all-important empty crisp packet (see 'Bits and Bobs' on page 16).

These SLRs (Single Lens Reflex camera and Small Lively Rodent) are all that you need to get started in pet photography – apart from the film and boundless patience.
Canon D30, 90mm lens, 550 EX flash

CAMERAS

35mm Single Lens Reflex Cameras (SLR)

The 35mm SLR camera is the most popular and best-supported of all the formats and there are a number of manufacturers offering an extensive range of cameras, lenses and accessories. The SLR is also the most practical and suitable type of camera for taking pictures of pet animals, especially as most modern models offer fast and reliable autofocus, which enables you to take both static and action shots. They also offer a high degree of automation, so that the photographer can concentrate on taking the picture and leave the camera to work out the difficult functions such as exposure, aperture settings and shutter speeds.

Most budget-priced SLRs offer various 'pic' modes. When using one of these settings, the camera chooses the most suitable combination of aperture (the 'in focus' zone) and the shutter speed for the subject matter. For example, the 'Portrait' setting ensures that the subject stands out by choosing an aperture that throws the background out of focus, while the 'Sports' mode ensures that the shutter speed is fast enough to freeze a moving object. For most pet photography, these modes are more than adequate and allow the photographer to concentrate on composing the picture. For those who wish to be more adventurous, all of these functions can be manually over-ridden, allowing the photographer to be more creative when picture-taking.

Nearly all of the current budget and mid-range SLR cameras are autofocus. As mentioned earlier, this is a distinct advantage when taking portraits of pets, as it allows you to concentrate on the composition of the picture. When composing a picture, always bear in mind that the focusing point of your camera/lens is over the subject matter that you want to feature, otherwise you may end up with a very blurred picture of your pet in a perfectly focused background.

Most models include built-in flash (useful for adding a highlight in the animal's eye) and a motorized film advance that is perfect for taking a series of action shots. Nearly all SLR cameras allow the photographer to attach accessories such as flashguns and filters to the lens to create special effects. Some of the more advanced models also allow the use of more powerful studio flash units.

35mm Compact Zoom Cameras

As with the SLR, there is a huge range of compact zoom cameras available, but these do have limitations, as they do not normally allow for the more powerful and useful accessory flashguns to be fitted. However, as far as pet photography is concerned, they are capable of producing excellent results, especially when used for outside portraits.

Like the SLR, most models offer a high degree of automation along with the standard pic modes. The more highly specified cameras allow photographers to choose their own settings, which permits greater creativity. The fixed zoom lens normally covers a focal length of between 28–70mm, which is perfect for most pet portraits and nearly all compact zooms have motorized film advance and built-in flash units.

There is a huge choice of compact zoom cameras. Although they do have limitations as far as pet photography is concerned, they are capable of producing some excellent images.
Canon D30, 90mm lens, 550 EX flash

Advance Photo System (APS)

In recent years, this new system has been introduced by many of the high street camera manufacturers. It has been designed to facilitate the automatic processing procedure, but it also gives the user the advantage of three different picture formats from the same film (classic, panoramic and horizontal).

The main benefit of the APS over traditional film is that you get a printed index sheet with the photographs, and the film loading system is very easy. Major manufacturers have introduced APS camera bodies that are compatible with their existing lens systems. However the APS format currently offers no advantage over traditional 35mm equipment.

Digital Cameras

Digital technology is advancing at a tremendous rate and nowhere more so than in the manufacture of digital cameras. Many of the photographs in this book have been taken using the most up-to-date digital SLR camera currently available but I expect that, by the time this book is published, the camera will have been superseded many times over. The biggest advantage of using digital is that it is immediate: you can take the picture, view it on the LCD (liquid-crystal display), download it to the computer, print it or even send it via e-mail to your family and friends. It is also the perfect tool with which to practise your techniques as, once the initial outlay for the kit has been made, there are no ongoing film or processing costs.

The APS (Advanced Photo System) is a relatively new camera format. It comes with either a fixed or zoom lens, or there are some models that allow interchangeable lenses.
Canon D30, 90mm lens, 550 EX flash

However, battery consumption is a major headache when using digital cameras: auto-focus lenses, LCDs and the numerous other electrical functions that the camera uses can drain battery power far quicker than a normal camera and this can catch you out if you are not prepared. So, if your camera takes normal batteries, be sure to have a good supply of spares. Many cameras use rechargeable cells so double-check that these are fully charged before setting out on a session. There is, after all, nothing more annoying than getting your pet into the perfect pose, only to find that there is a little red light flashing in the viewfinder and nothing works.

One final word of warning: a digital camera is full of electronic gadgetry and, if it gets wet, the circuitry may never work again. Consequently, it is important to protect it from the rain and keep it out of damp conditions. Condensation can also form inside the camera if you come into a warm house after taking pictures of your dog running in the snow. It is best to leave the camera in the room until the condensation has evaporated, as switching it on could lead to the electronics shorting out and doing irreparable damage.

The Chip

The heart of any digital camera is the CCD (charged coupled device) or CMOS (complementary metal oxide silicon) chip – the digital equivalent of traditional film. The chip is basically a grid of extremely small light-sensitive cells. When light reaches these sensors (also known as pixels), an electrical signal is produced and it is from the resulting pattern that the digital image is built up. Obviously, the more pixels that can be built onto the chip the finer the detail in the image will be, and this is the challenge faced by manufacturers of digital cameras.

There are many different models of digital camera to choose from. Their biggest advantage is that the images can be downloaded to a computer and viewed within a matter of minutes – a big bonus when photographing pets.
Canon D30, 90mm lens, 550 EX flash

Currently, the highest specified digital cameras have around three to four million pixels. However, if you compare a piece of 35mm negative film, you would find that it uses tens of millions of grains of silver (the equivalent of the digital pixel) to capture the image. You would therefore be quite right in assuming that the quality of digital images cannot compare with that of film; however, remember that the human eye has limits to how much detail it can see, especially when looking at a picture from a normal viewing distance.

IMAGE STORAGE

Once your camera has completed the electrical wizardry to capture your image, it has to put it somewhere. The trouble with digital files is that they take up a huge amount of storage space. All digital cameras will give you a choice of taking pictures at different resolutions (high, medium and low quality). Obviously, the higher the quality, the larger the file. In the early days, digital cameras had built-in storage disks and this severely limited the number of pictures that could be taken before they needed to be downloaded to a computer.

The answer to this problem is removable storage disks (more commonly called 'cards') that can be replaced when full, just like film. There are three types of card on the market: CompactFlash, SmartMedia and microdrive. CompactFlash and SmartMedia are the two in most common use. They vary in capacity from 16 to 512 megabytes and the larger cards can store hundreds of high-quality images.

The microdrive is quite simply a very small hard drive, similar to those used in PCs. Microdrives can hold a huge amount of data, especially as they are now being manufactured in sizes of up to five gigabytes. They tend to be slightly less robust than solid-state cards and they do not stand up to very rough handling.

Digital cameras usually use either CompactFlash or SmartMedia cards so, once you have chosen your camera, you are tied to the storage system. However, some cameras can use both CompactFlash and microdrives, giving the photographer a choice of using one or indeed both systems in tandem.

Be prepared for a shock when looking to buy any storage cards, as they are very expensive, but they can be erased and used time and again.

The three main types of storage for digital cameras: SmartMedia, CompactFlash and microdrives.

LENSES

A camera is of no use without a lens and the choice for 35mm SLRs is truly vast. One of the biggest advantages of this format is that the lenses can be interchanged and, for the majority of us, the compromise is to purchase a zoom lens. Fortunately pet photography does not require super-wideangle or huge telephoto lenses, which can be extremely expensive.

A standard zoom lens with a focal length of around 24–80mm will cover most eventualities. However, in some cases the extra working distance that a telephoto zoom can give, with a focal length of 75–300mm, may be an advantage. This is especially true when taking pictures of a sleeping cat or dog, which must not be disturbed, or skittish pets such as ferrets. These lenses have the advantage of being readily available. In fact most budget-priced SLRs will be sold as part of a kit, which includes a standard zoom. The existence of numerous independent manufacturers means that they are also reasonably priced.

Lenses come in a variety of focal lengths. The ideal one for general pet photography is a zoom lens that covers 24–80mm.

FILM

It cannot be stressed enough that the quality of the film used has a direct effect on the final image. Use inferior film and you will get inferior results: it is that simple. Another factor to be taken into account is the importance of using the right type of film for the job. Film can be divided into two types: negative (colour and black and white) and transparency, also known as slide film. With the increase in digital cameras you could include digital film, but the purists might not agree.

Photographers are spoilt for choice when it comes to brands of film. Generally, the well-known makers such as Kodak, Fuji and Agfa are a safe bet but, when choosing film, do not dismiss the 'own brands' as the quality of these can be excellent. Most professional photographers stick with a favourite brand and this is sound practice for the aspiring pet photographer, too.

Negative Film

It is estimated that many millions of photographs are taken each year and it is a fair bet that the majority of them are taken using negative film. Once the film has been processed, prints are then produced. The photographs can be printed in various sizes and the obvious advantage of this is that your pictures can be proudly shown to members of your family and friends.

Another advantage of negative film is that it is very forgiving during exposure. It has wide latitude and can therefore deal with reasonable degrees of under- or overexposure, which can be a problem when photographing very light or very dark animals.

Whether you use negative film for prints or transparency film for slides, the quality of the film you use will have a direct effect on the final image.

Transparency Film

This type of film is more commonly known as slide film. Photographers normally use a slide projector and screen to view slides properly, but portable viewers can be purchased.

It is generally felt that slide film gives better quality pictures than negative film, as there is only one stage in the developing process and therefore less degradation of the image. Prints can be made from transparencies, but they tend to be rather expensive and the quality may not be as good as the original.

Transparency film does not have a very wide latitude and therefore some exposure compensation may be needed to ensure that the image is not under- or overexposed.

Film Speeds

Film speeds range from ISO 25 through to ISO 6400 and, in general terms, the lower the number the higher the image quality. However, there is a pay off for this quality: the film will need to be exposed longer, which can lead to unacceptably long shutter speeds causing blurred images due to camera shake. For the majority of pet photographs, a film speed of between ISO 100 and ISO 400 is perfectly suitable.

ACCESSORIES

It has already been said that you do not need mountains of photographic gear to take successful pet portraits. But – apart from the obvious things like a camera, lens, and film – there are a few items which will make the job easier, and enable you to turn that ordinary picture into something special.

Accessory Flashguns

Accessory flashguns come in all shapes and sizes, and can be surprisingly inexpensive considering the difference they can make to your photography. Ideally, you will need one that is dedicated to your camera. This does not mean that you have to purchase one made by your camera manufacturer, but simply that the flashgun and the camera must be compatible, and able to communicate with each other via tiny computers. This communication is vital to ensure that the film is correctly exposed and the right amount of light is transmitted from the flashgun, so check with your photographic dealer before buying. You can purchase non-dedicated flashguns but, if you do, you will have to calculate the shutter speed and aperture settings manually.

Flashguns normally attach to the top of the camera via a hot-shoe fitment. This will still locate the flash above the axis of the lens; this is not ideal but, because it is higher than the built-in unit, there is less chance of 'green eye' (see page 72).

When you are purchasing a flashgun, try to buy one with a tilt-and-turn head. This will enable you to bounce the flash from a ceiling or wall to help prevent unwanted shadows (see page 73). Another good rule of thumb is to purchase a flash that has a good 'guide number'.

The guide number (GN) of a flashgun will indicate the maximum power output and the distance over which it will be effective – the bigger the number the greater the output. The guide numbers are stated in metres for a film speed of 100 ASA. Most built-in flash units will have a GN of around 10, which will equate to a coverage distance of 10 metres (approximately 30 feet). This might seem enough for most pet photography but do not forget that the light will fall away as the distance increases. A useful GN to aim for is around 30, which gives enough power to allow some distance from the subject matter.

The other factor to bear in mind is that the flashgun must cover the focal length of the lens. The average flash beam will cover an angle suitable for a 35mm lens. However, if you buy one with a zoom head, this will allow the beam to cover a wider range of focal lengths, usually from 28–80mm.

Accessory flashguns will enable you to expand your photographic horizons. Apart from providing illumination when photographing inside, they can be used to good effect during bright sunlight to soften the shadow areas.

Exposure Check Lamp

Another useful feature is an exposure check lamp – a small light that illuminates if the subject is within range. It has a test button which can be used to fire the flash without tripping the camera's shutter button, and this can be used to check that the animal is in range and will be exposed correctly. It can also be used to see how the animal will react to the sudden burst of bright light.

The thyristor is a small circuit that is found inside automatic flashguns and the sole purpose of this piece of electrical wizardry is to store the unused energy after a picture is taken. This reduces the flash recycling time and saves expensive battery power. There is, however, one hidden benefit of great advantage to pet photographers. When the flash is charging, the thyristor makes a high-pitched whine that is very hard for humans to hear unless the flash is held close to the ear. An animal's hearing is far more acute than ours and quite often you will see the animal cock its head in an effort to work out where the noise is coming from – that is the time to take another photograph.

Off-camera Sync Cable

This very useful accessory, which can be purchased for most flashguns, allows the flash to be used off-camera and gives you greater creativity when taking photographs. You will also have to buy a socket that fits into the hot shoe of the camera, and then attach the flash to the camera via the synchronization cable. Before buying, check with your supplier that the cable will allow the flash to keep its dedication facility with the camera.

Monobloc Flash-heads

If you want to take your photography to another level, you should consider larger flash units. The most practical type for pet photography is known as a monobloc unit, which simply means that the power supply and lighting unit are built in together and draw power directly from the mains rather than a separate power unit.

There are some very reasonably priced monobloc units on the market. You do not necessarily need a host of features, but choose one that has a built-in modelling light and which allows you to vary the power output. In the majority of cases, there is no need to use more than one light, unless you plan to photograph large groups of animals, in which case you may need anything up to three separate units.

Monobloc units do call for an in-depth understanding of flash photography, though, as they are not automatic and the shutter speed and aperture on the camera must be set manually. There is no facility to allow the camera and flash unit to 'talk' to each other as with a dedicated flashgun and, therefore, the photographer will need to use a flash meter to establish these settings. There are many good books on the market, as well as photographic courses and, if you plan to invest in one or more monobloc units, I strongly recommend that you spend time learning the art of using this type of equipment.

The main advantage of monoblocs is that they tend to be more powerful and, because they run from the mains electricity supply, they recharge faster. This allows you to take your photographs more quickly, which may be vital if the subject is becoming bored. Another useful feature is the modelling light, which will show you where the shadows will fall when the flash is fired. Flashguns tend not to have this facility.

Flash Meter

If you plan to use monobloc units you will also need a flash meter (to read the light output) and lighting stands. Also, your camera will need a PC socket so that a sync cable can be attached. This will make sure that the flash unit fires when you press the shutter button.

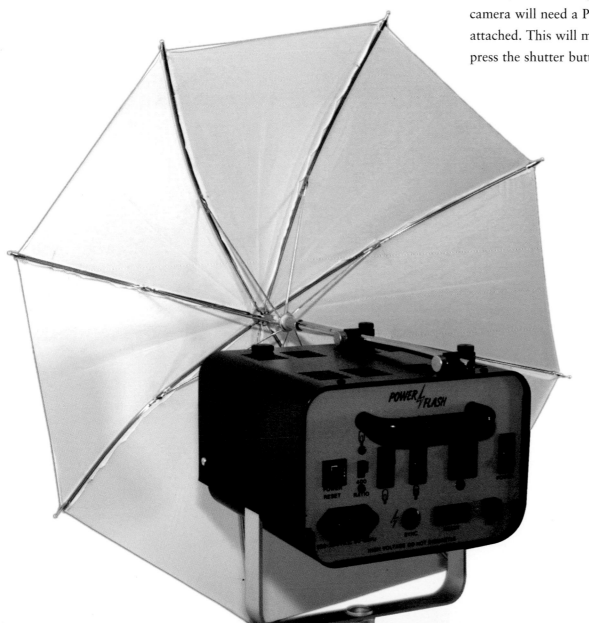

Monobloc flash units require a better understanding of flash photography techniques but, once mastered, will take your photography to another level. This relatively cheap unit has a 'shoot through' umbrella attached.
Canon D30, 50mm lens, 550 EX flash

Tripods

Tripods can be invaluable and my advice is to buy the best you can afford – a wobbly tripod is worse than not having one at all. The obvious benefit of using a tripod is that it will prevent blurred pictures caused by camera shake, but the biggest disadvantage is that it will restrict your movement and, when trying to keep up with a fast-moving and camera-shy pet, this can prove extremely frustrating.

I very rarely use a tripod for my pet photography, as I prefer to have the freedom to move angles. In any case, when using an animal's home as a background, there is often no room to manipulate the tripod, lights and the model.

Reflectors

The word photography literally means 'painting with light' and one of the simplest ways of manipulating light (especially natural sunlight) is to use a reflector. These can be bought from any good photographic shop and normally consist of a flexible frame with a covering of highly reflective material. You can buy them with silver, white, or gold covering and each one will have a slightly different effect on the reflected light. However, if you are only going to need one occasionally, why not make it from a piece of card and some silver foil, or even more simply, a white sheet of paper or a piece of old bed sheet?

The main reason for using a reflector is to throw light into the shadow areas (the side opposite to the light source) and to put that all-important highlight into the animal's eyes.

Bits and Bobs

There are numerous useful bits and pieces that can help to create a picture of a lifetime as opposed to just another ordinary photograph. One of the most important pieces of kit that I carry in my camera bag is an empty crisp packet. When scrunched up in a hidden hand, even the best-behaved dog can't resist cocking its head in an effort to work out where the noise is coming from.

Pieces of string can be used to tempt a sleepy cat into a fit of excitement and alertness. A word of warning though, a client of mine used a very expensive diamond necklace to cajole an elegant Persian cat into action. The cat took one well-aimed swipe at the necklace and it ended up in the fireplace. One very embarrassed owner, but one very good picture!

Squeaky toys, balls, or fluffy mice attached to flexible rods can all be used to get a reaction out of your pet as can a multitude of man-made whistles, chirrups, squeaks and clicks. Quite simply, if it works then use it.

Squeakers, cat toys and the ever-reliable empty crisp packet will all help to encourage your pet to look alert and inquisitive during the session.

SUMMARY – TOP TIPS

◆

USE AN AUTOFOCUS FILM OR DIGITAL CAMERA

◆

USE A STANDARD ZOOM LENS WITH A FOCAL
LENGTH OF 24–80mm, OR 70–300mm WHEN YOU
NEED MORE DISTANCE BETWEEN YOU AND
YOUR SUBJECT

◆

USE NEGATIVE FILM WITH A SPEED OF
ISO 100–400

◆

USE AN ACCESSORY FLASHGUN OR A REFLECTOR
TO SOFTEN SHADOWS AND PUT HIGHLIGHTS
INTO DARK EYES

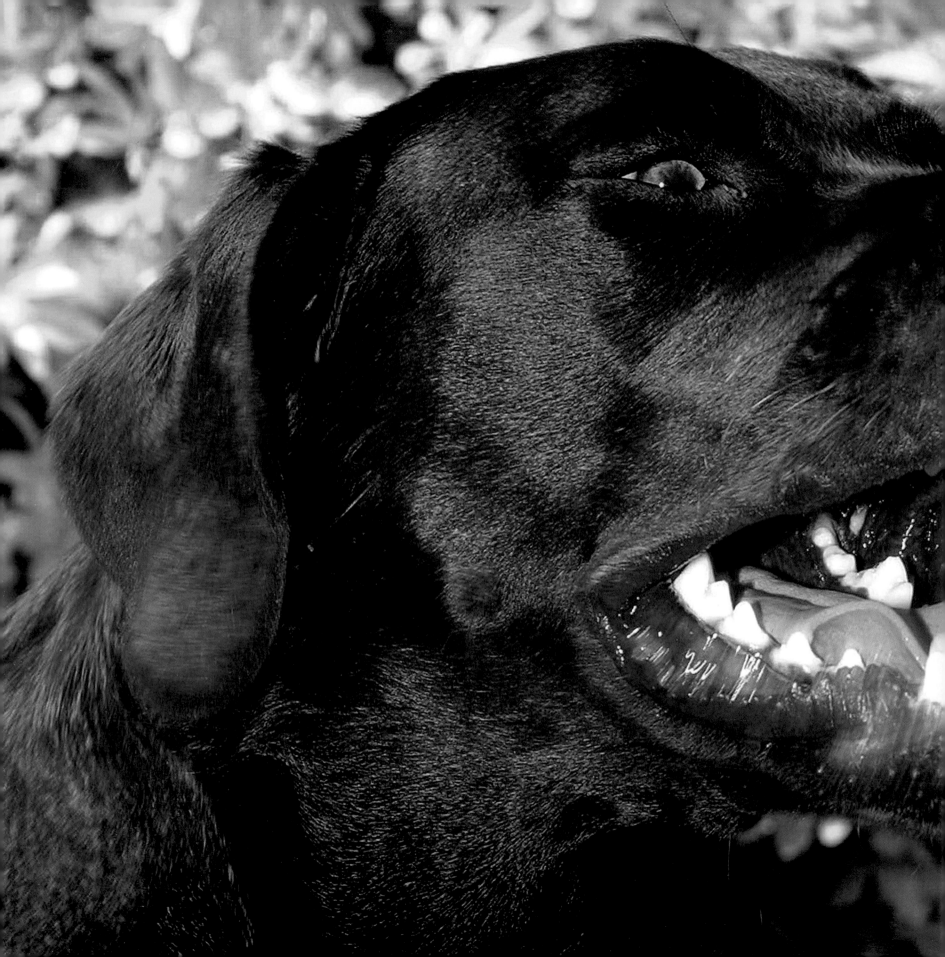

Chapter 2

Animal Behaviour

This dog is showing the classic signs of having its fear circle invaded, by leaning away from the photographer in an effort to increase the distance. The next stage would be to either run away or to attack. In these circumstances it is better to move away and allow the animal time to relax and then use a longer lens to keep an acceptable distance from the subject.
English springer spaniel
Canon D30, 28–135mm lens, 550 EX flashgun

This book is not meant to be a definitive guide to animal behaviour but, to get the best out of your pet model, it will help to have some understanding of the animal mind. Most owners will already have a very personal understanding of their pet's habits and unique character and this knowledge should be used to the photographer's benefit.

FEAR CIRCLE

All birds and animals, including humans, have what is known as a fear circle. In humans it is called personal space – an undefined area in which we feel uncomfortable if somebody comes too close without our invitation.

In animals and birds, it is a highly developed instinct to run or fly away from danger should a predator come too close. In most cases we do not have to worry about the fear circle when photographing pet animals such as dogs and cats, as they are quite accustomed to human contact. However, when photographing an animal you do not know, be very aware of this phenomenon and take the necessary precautions, such as using slightly longer lenses and keeping a suitable distance from the animal.

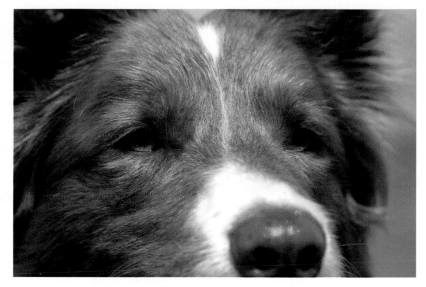

A bold, confident animal will allow you take very close and personal images of its face and eyes. Use a telephoto or zoom lens to give a comfortable working distance between you and the subject.
Red Border collie
Canon D30, 28–135mm lens

This golden retriever is showing signs of wanting to avoid eye contact with the camera, by turning its head away and looking very apprehensive and nervous. Occasionally it turned back to the camera and growled.
Golden retriever
Canon D30, 28–135mm lens, studio flash units

EYE CONTACT

Eye contact is all-important in the animal world. How many times have you glared at your dog or cat when it has misbehaved and its reaction has been to turn away in an effort to avert the stare? Fixed, staring eyes often act as a threat to other animals and can be very intimidating, not a reaction that you wish to create during a relaxed photographic session.

Quite often when taking photographs your eyes are hidden behind the camera, so you may consider that there is no 'threat' to the animal. However, the bright reflection of the lens can resemble a huge staring eye and can quickly unnerve even the most confident of pets. It is very important that either you or the owner talk confidently to the the animal until it begins to relax. It may be a good idea to lower the camera a few times so that the animal can see your face – it will then soon realize that the metal box with the scary eye is not a threat to its well-being. At the same time, speak softly and continually to reassure it that you and the camera are not a threat.

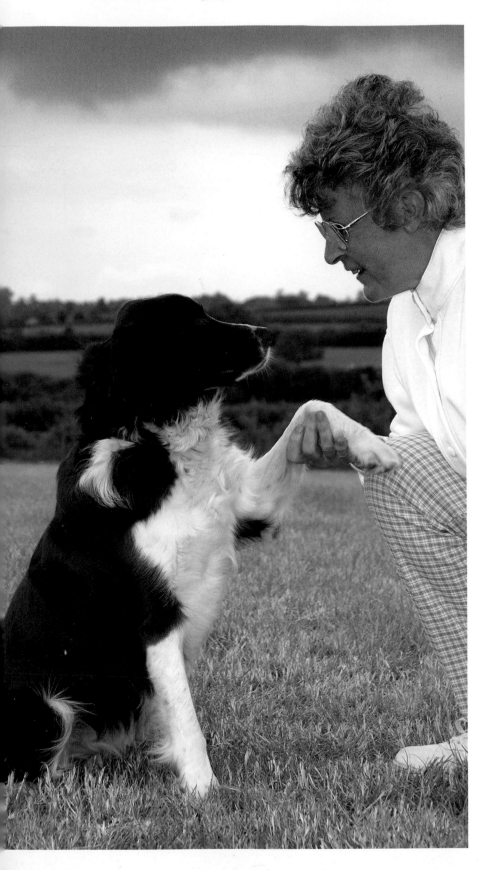

THE PACK INSTINCT

Dogs are nearly always suspicious of strangers and so, if you are undertaking a portrait-sitting for a friend or client, you should have some understanding of the animal's reaction when you visit its home territory.

When first entering a house, never take your camera bags and equipment with you. Many dogs will bark and jump and want to sniff this new visitor. During these first few frantic moments, you will need both sets of hands to greet the dog and start the vital bonding, which will result in the animal relaxing and accepting you into its 'pack'. When the initial greetings have subsided and the inevitable presents of chewed slippers and mouldy tennis balls have been accepted, this is the time to collect the camera gear and start snapping.

Cats, on the other hand, are a totally different matter. They tend to be rather aloof and, in some ways, use humans as a means to an end. They are quite capable of looking after themselves and will come and go as they please. They do, however, tend to react quite differently when a stranger enters their world.

Dogs are pack animals and see their owners and immediate family as an integral part of the group. They will nearly always be suspicious of strangers and you should always take the time to greet the animal and 'make friends' before taking the camera out of the bag and starting to take pictures.
Cross-bred spaniel and owner
Canon D30, 50mm lens, 550 EX flash

Bold, confident cats will greet you by rubbing their heads and body against your legs. Here, they are exchanging scent, which helps to make the cat feel more comfortable with its human companions. If the cat is dozing when you enter the room, it may well roll over on to its back and show you its belly. This could be taken as a display of total trust, as the underside of any creature is the most vulnerable part to expose to a predator. However, be slightly cautious as a friendly hand reaching out to stroke the cat can be met with a well-aimed swipe of a claw.

Belly-rubbing is normally saved for special members of the family. Take time to greet the cat and gain its acceptance. Five minutes of purring and mutual grooming will pay dividends in the long run.

A confident cat may well greet you by rubbing its head on your legs or by rolling over on to its back to show you its belly. However, be careful when reaching out to stroke the cat – your hand could well be met by a well-aimed swipe of a claw.
Tabby cat
Canon D30, 28–135mm lens

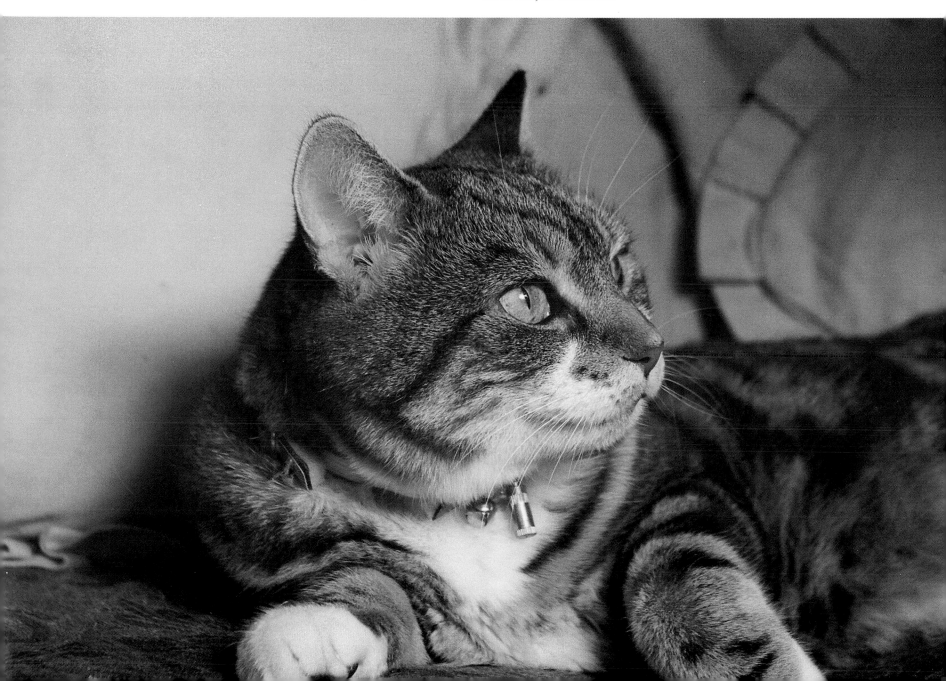

A mid-way wag is the sign of a happy dog. In breeds such as this cocker spaniel it can be difficult to stop the tail from creating a blur in the photograph, as the tail action is so fast.
Cocker spaniel
Canon EOS 5,
28–135mm lens

THE TAIL END

It is very easy to understand the signals that the front end of any pet gives out. For example, if a dog is snarling and showing its teeth, there is a good chance that the wrong move may prompt it to attack you. If a cat's ears are lying flat on its head and the animal is spitting at you, the chances are that it will scratch and possibly bite if you try to pick it up. But what goes on at the back end is probably more complex and in many ways more important.

Interestingly enough, tail wagging by a cat is generally thought to denote very different feelings from a dog's tail wagging: a dog wags its tail because it is happy, while a cat twitches its tail because it is angry. The simple fact is that, in both sets of creatures, tail wagging is a sign of conflict within the animal – in basic terms, it is not sure what action or reaction to take in response to a particular situation. As I have already stated, this book is not about animal behaviour and whole chapters could be written about 'tail wagging'. However, that is not my intention, but we can draw some conclusions that are beneficial to us as photographers.

A dog's tail will normally wag in three positions: upright, mid-way and between its legs. All three positions give out different signals. If a dog greets you with its tail in a very upright position (almost like a flag-pole) it is displaying an aggressive, dominant posture and may be quite protective of its territory. A mid-way wag is a good wag: generally the dog is approachable and happy to interact. A tail-between-the-legs wag is indicative of a nervous dog and one that is unsure of your intentions. A dog displaying this type of reaction will need time to gain confidence in you, so it would be highly irresponsible to try to take any pictures until the dog is feeling comfortable in your presence. If you learn to read your subject's body language, you will greatly improve your success rate.

Tail positions:

Aggressive/dominant

Confident/happy

Nervous/scared

Tail position can give the pet photographer a good indication of how the animal is feeling and how it might react in any given situation: an erect tail can indicate a dominant or aggressive animal; a mid-way tail is indicative of an animal that is happy and confident; on the other hand a tail that is tucked under the body shows that the animal is nervous and unsure of your intentions.

The initial observations that you make about the dog and its tail position can give a number of clues as to how it will react during the photography session. When you start pointing shiny lenses and flashing bright lights at a reluctant model, you will not achieve the relaxed, intimate pictures that you set out to create.

When a cat wags its tail, it is again showing signs of conflict going on within it. It may be that you would like to move the cat to a more suitable position to take the pictures, but it is quite comfortable lying in front of the fire. As you approach, the cat may read your intentions and start to gently flick its tail. This should be taken as a warning signal and an indication that you should try an alternative tactic to moving the cat. Of course, the cat may react differently to the owner, or someone who knows it well.

If the tail is swishing from side to side vigorously, then consider taking the pictures another day, because this cat is not happy and is probably best left alone.

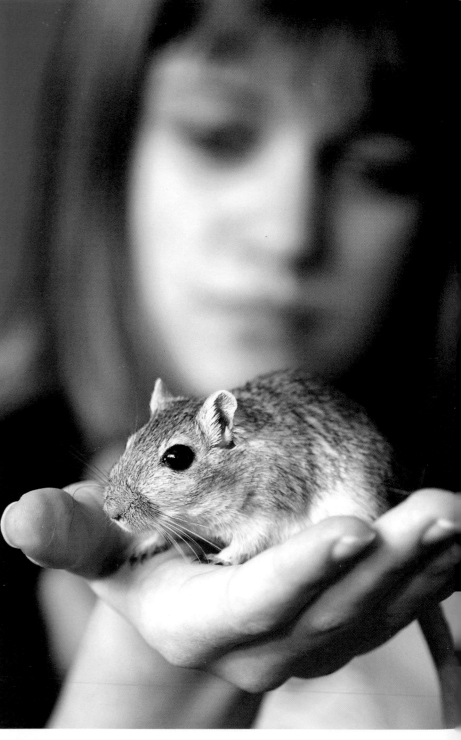

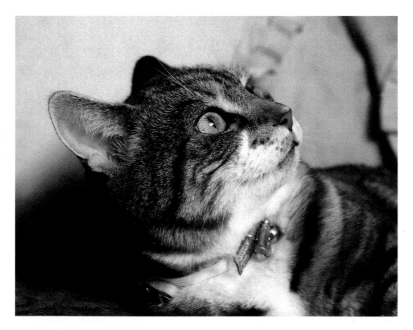

When photographing cats you might need to move the animal to a better location but the cat may be quite comfortable and will read your intentions: the tail will start to flick and its ears will start to flatten against its head. These are all warning signals and it would be better to leave the cat where it is and try to re-think your session.
Domestic short-haired tabby cat
Canon EOS 5, 28–135mm lens

Small creatures, such as gerbils and hamsters, should never be picked up by their tail. Use a gentle handler to help you with the photographs. Here, a large aperture was used, so that the handler is thrown out of focus and the emphasis is on the gerbil.
Gerbil
Canon D30, 90mm macro lens, f/4.0

Tails are important to most animals and to understand the complexities of this appendage, it is useful to bear in mind the following generalizations:

◆ A tail that is bushed out, similar to a bottlebrush, indicates that the animal is either in an aggressive mood or is scared. If you are not careful, there is a good chance that you may get bitten or scratched. In cats and ferrets this is a classic sign of an unhappy animal.

◆ Tails are not handles to either hold or pick up the animal. In small creatures, such as gerbils, you could quite easily pull off the tail with inappropriate handling.

◆ In some reptiles, such as iguanas, the tail is used as a weapon by being whipped out very fast. In others, it has an unfortunate habit of departing from its owner's body, enabling the animal to escape from a predator.

◆ Tail signals should not be interpreted in isolation. They are part of the whole body language of the animal and sometimes can be easily misread. One dog that I encountered was wagging its tail while trying to bite me – does that mean it was enjoying scaring the living daylights out of me?

Understanding animal behaviour is a complex science and, in today's world, studying and analysing animals and their interaction with humans and each other is big business. We, as pet animal photographers, need to be aware of such matters but, more importantly, to have an affinity and be comfortable with our animals. When I meet a new dog or cat, I do not consciously watch its tail or observe its every move, I simply do what I have done for the past 30 years. It now comes naturally and I don't even think about it. All I know is that I usually end up playing ball with the dogs, or having my lap kneaded by some contented cat, before I even get the camera out of the bag.

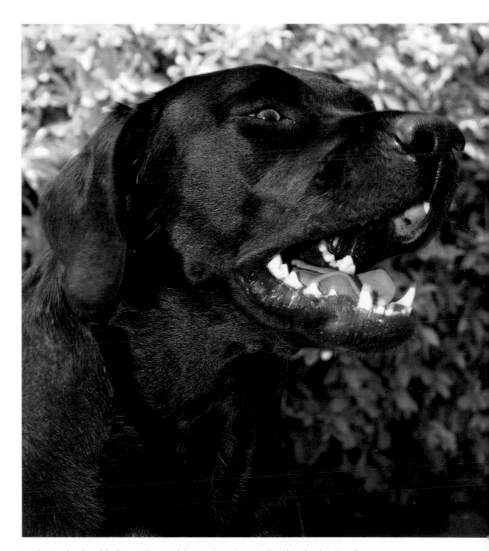

Tail signals should always be read in conjunction with other body signals. In the case of this Labrador the signs are quite clear: if you continue to point that camera at me, I will bite you!
Black Labrador retriever
Canon D30, 28–135mm lens

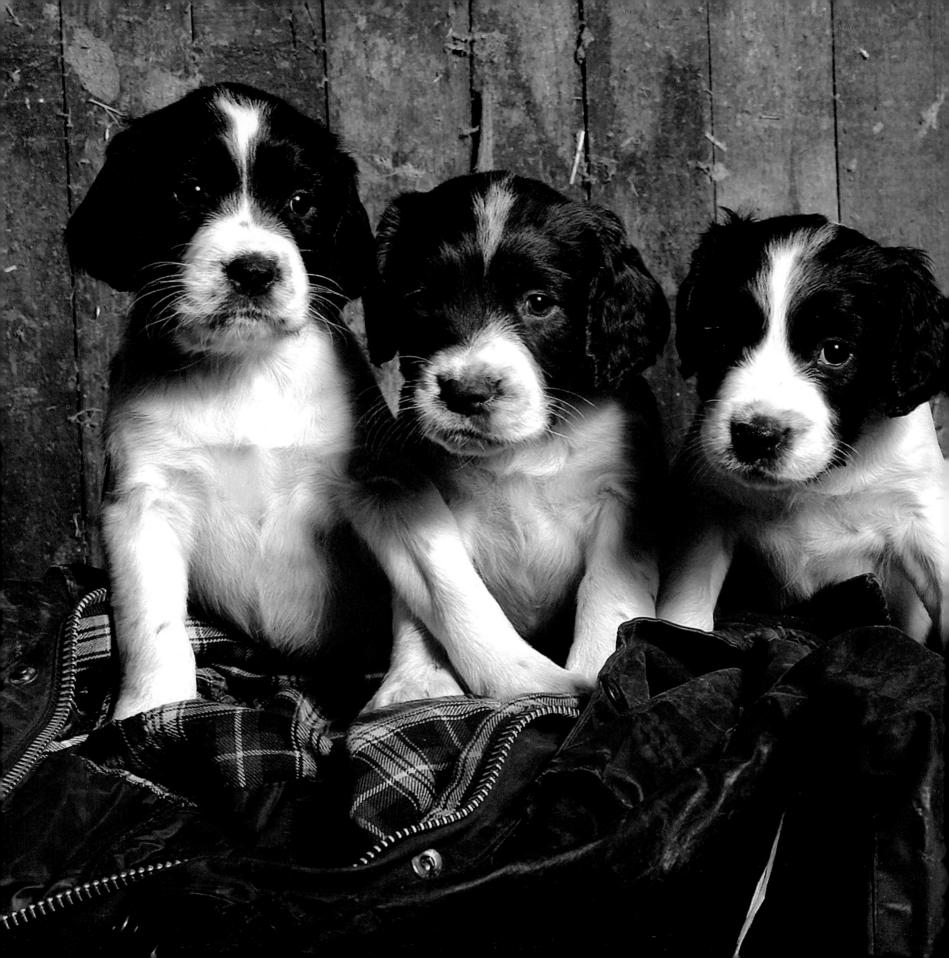

Chapter 3

Natural/ Environmental Portraits

One of the biggest advantages of photographing a pet in an outdoor setting is that you can show the animal in a more varied and interesting environment. However, careful thought has to be given to the background and lighting direction and it's also important to ensure that you use a suitable location for the type of animal that you are photographing. A Border collie dog will look perfectly at home photographed in an old barn surrounded by chickens and farmyard equipment. Put a Pekinese in the same location and the picture will just not work.

Before venturing into the big wide world to take portraits, there are a few technical points that you should take into consideration, not least the way in which the aperture and shutter speed will affect the photograph and how you can use these two aspects of camera control to your advantage. Most SLR cameras will allow some manual adjustment of the shutter speed and aperture setting, whereas many compact zooms have a fixed lens and do not allow such adjustments.

The aim of any budding pet photographer should be to try and capture the animal's personality, and what better way to do this than in the great outdoors. Whether you use a back garden or an old barn, understanding lighting and composition will help you to create that once-in-a-lifetime portrait.
Australian shepherd
Canon D30, 28–135mm lens

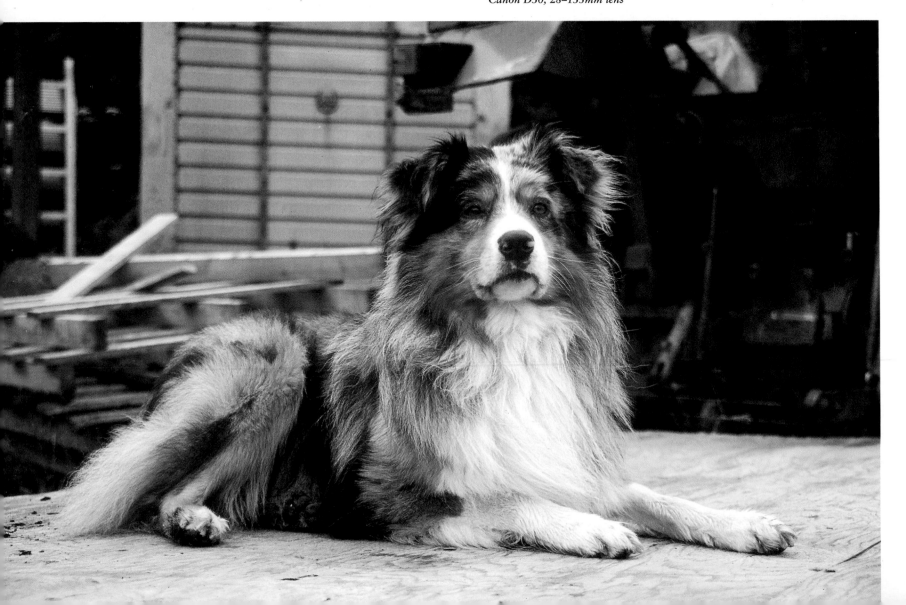

CONTROLLING THE APERTURE

The aperture on the lens controls the acceptably sharp zone of focus (depth of field) and the amount of light entering the camera to expose the film. Aperture settings are expressed as 'f stops' and range from f/1.4 through to f/32, although some specialist landscape lenses will open to f/64. Understanding the importance of the aperture setting and its control of the depth of field is important to pet photographers. As with all photographic portraiture, the main point of focus is usually the subject's eyes and this is no different when photographing pets. However, there is one physical difference in animals that will affect the way the camera settings are controlled.

A shallow depth of field (f/1.8) only leaves the eyes in sharp focus; the nose chest and ears are slightly blurred, as is the background.
Collie x greyhound lurcher
Canon D30, 50mm lens, 1/4000sec at f/1.8

Medium depth of field (f/5.6) renders the eyes and nose in an acceptable focus and the background is sufficiently blurred so as not to be distracting.
Collie x greyhound lurcher
Canon D30, 50mm lens, 1/350sec at f/5.6

Most of the image is in sharp focus including the background, which is starting to compete with the main subject
Collie x greyhound lurcher
Canon D30, 50mm lens, 1/45sec at f/16

In the majority of pet animals, the ends of their noses extend some way from the main point of focus, the eye. In dogs such as greyhounds, this can be as much as 15cm (5–6 inches) and so, if you do not set a suitable aperture, the end of the nose will be out of focus and will be very distracting when viewing the photograph. The depth of field of a lens extends one third forward and two thirds behind the point of focus and, therefore, a setting of at least f/5.6 will be needed to ensure all parts of the animal's face are in sharp focus. If you own a fixed-focus compact camera, do not worry too much as most of these types of cameras have a fixed aperture of at least f/5.6 which should allow acceptable images to be taken.

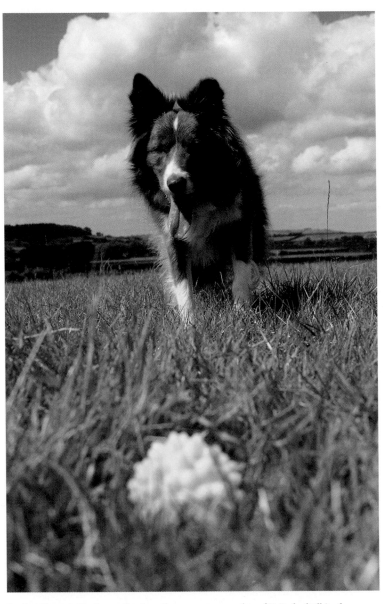

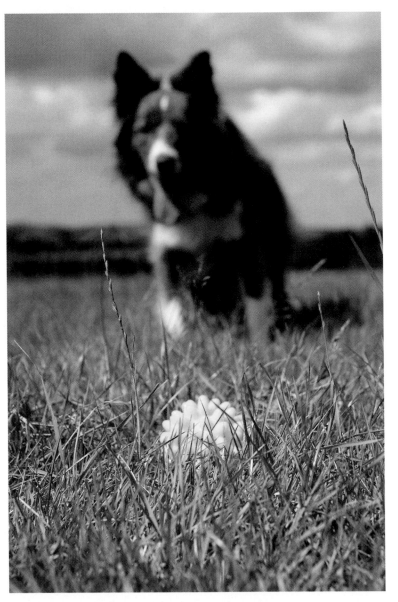

By focusing on the dog and using a large aperture such as f/2.8, the ball in the foreground is sufficiently thrown out of focus so as not to be distracting. The bright yellow complements the colouring of the dog, the grass and the blue of the sky.
Red Border collie
Canon D30, 28–135mm lens at the 28mm end, f/2.8

In this image the focusing point has been reversed and it is the ball that is the main point of interest. The dog and the background are blurred and overall the picture is not as pleasing to the eye as the previous example.
Red Border collie
Canon D30, 28–135mm lens at the 28mm end, f/2.8

CONTROLLING THE SHUTTER SPEED

Controlling the shutter speed is important if you want to show your pet in action and to portray movement. In simple terms, a fast shutter speed will freeze a moving subject and may give the impression that it is static, while a slow shutter speed will produce a blurred image to enhance the impression of movement. Modern day cameras that allow you to set the shutter speed will offer settings from 1/8000 of a second to 30 seconds. The fastest setting will freeze a running dog, whereas the slowest will produce nothing more than a total blur. There are a number of techniques that can be implemented when using slow shutter speeds such as panning with the subject (see Action Shots, page 105).

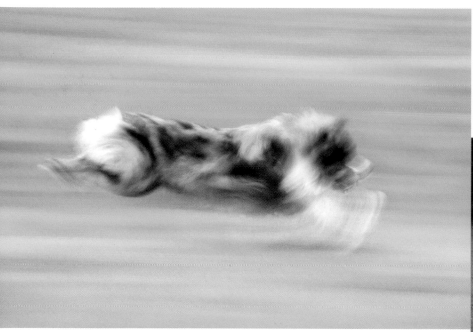

A slow shutter speed of around 1/15sec will produce a blurred image that will enhance the feeling of speed, especially when used with the panning technique (see page 105).
Australian shepherd
Canon D30, 28–135mm lens, 1/15sec

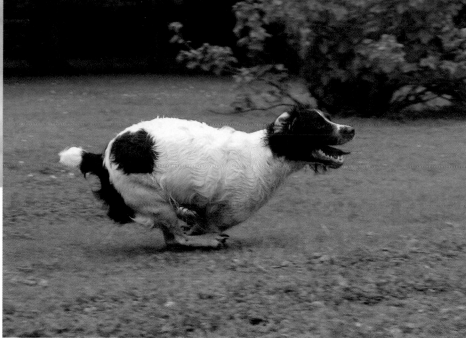

A fast shutter speed such as 1/500sec will freeze the animal in mid-action. Although it does not give the impression of speed it does enable you to show the amazing agility of your pet.
English springer spaniel
Canon D30, 28–135mm, 1/500sec

IDENTIFYING THE SETTING

For many of us, the ideal location for taking outdoor portraits is on our own doorstep – the garden. The animal will be at its most relaxed while in its own environment and the humble garden can offer innumerable locations in which to take natural photographs. Gardens offer many different backdrops such as flowerbeds, hedges, trees and fence panels, all of which can be used to give a neutral, clean and interesting background.

When trying to identify a suitable setting, try to divide the area into mini-sets. In the majority of portraits, only a small part of the garden will be used and you should be able to identify quite a few suitable areas. Avoid backgrounds that have brightly coloured flowers, as these may draw the eye away from the main subject, and be prepared to spend a lot of time on your stomach.

Dogs

Many working-type dogs, such as Labradors, spaniels and collies, lend themselves well to photographs in a more rural environment such as woods, parkland or even farmyards. However, the same basic rules apply: aim to keep the background clean and neutral – unless you want to make a feature of it – and, if you are photographing a dark-coloured animal, make sure that the backdrop is not in shadow, as this might make the subject 'merge' into the background, leaving no definition between the animal and its surroundings.

If you have a 'town' dog, consider using the local park, but include some of the buildings in the background, as your aim is to put the animal in its natural or normal environment.

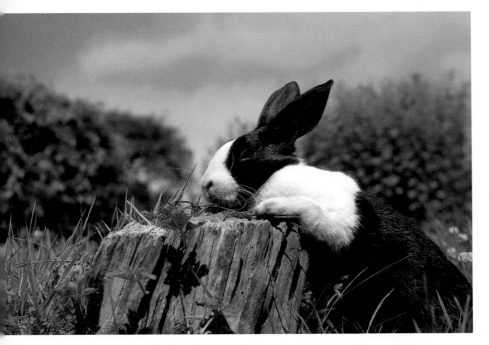

Look for interesting features in your back garden – a convenient log or tree stump can be used as a prop.
Dutch rabbit
Canon D30, 28–135mm at the 28mm end, f/5.6

If you live in a large town or city, photograph your dog against the backdrop of urban life. You may need to use a wideangle lens (28–35mm) so that you can include plenty of the surroundings. Position your dog so that it is looking into the image as though it is surveying its territory.
Mongrel
Canon D30, 28–135mm lens at the 28mm end

If your dog is not used to being around livestock and you are using a setting where there are other animals, it is vital to ensure that it is under proper control. In this situation, it would be a good idea to have another family member – or the owner – present to keep an eye on the dog while you concentrate on taking the photographs. The opportunities for taking natural or environmental photographs of dogs are endless and you will find that, once you get an eye for identifying a suitable location, your portraits will automatically be more rewarding.

Dogs such as this spaniel and lurcher lend themselves well to being portrayed in a rural environment. The late winter sunshine has given the picture a warm glow and the snow has helped to reflect the limited light.
English springer spaniel and collie x greyhound lurcher
Canon D30, 50mm lens

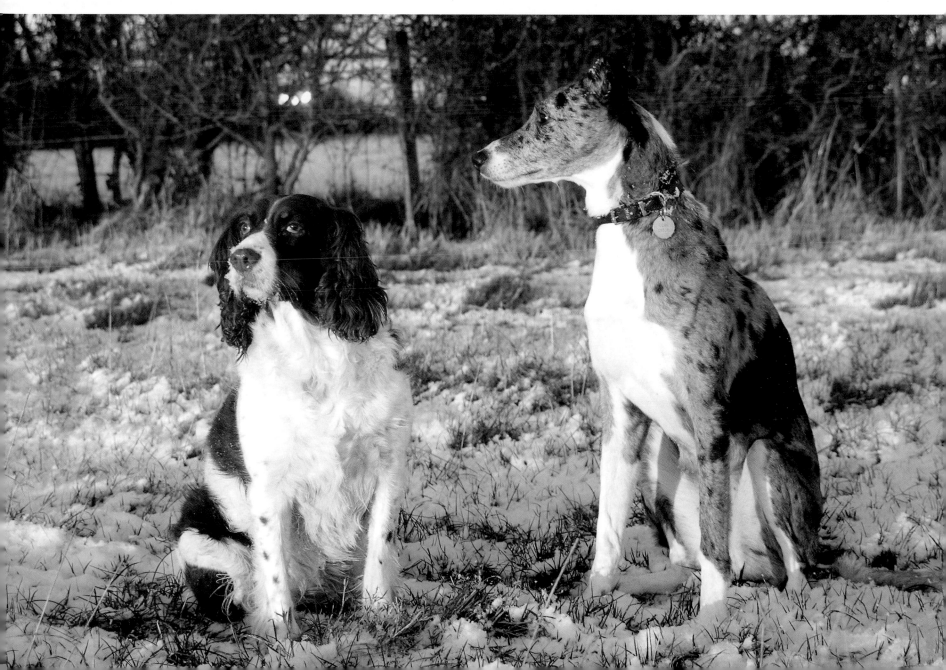

The best place to capture images of your cat is in the confines of your garden. If your cat lives outside, try to capture some of the buildings as a backdrop, so that the picture gives an impression of the kind of life your pet has.
Domestic short-haired tabby kitten
Canon D30, 28–135mm lens

Cats

In certain ways, you are more restricted when taking outdoor portraits of a cat. It would not, for instance, be wise to take a cat to the local park to be photographed. Apart from the obvious problem of numerous dogs looking to create mischief and mayhem, the cat is quite territorial and will not be very relaxed in a strange environment.

The garden is the perfect place to snap informal and relaxed images. Most cats have favourite places where they like to doze and lounge in the sun, or stalk through the long grass in an effort to catch an unwitting bird. Cats and trees are the perfect photographic combination: the dappled light through the leaves can give a very soft and even illumination that is ideal for taking portraits. Trees are also useful for excluding unsightly and undesirable background subjects such as buildings.

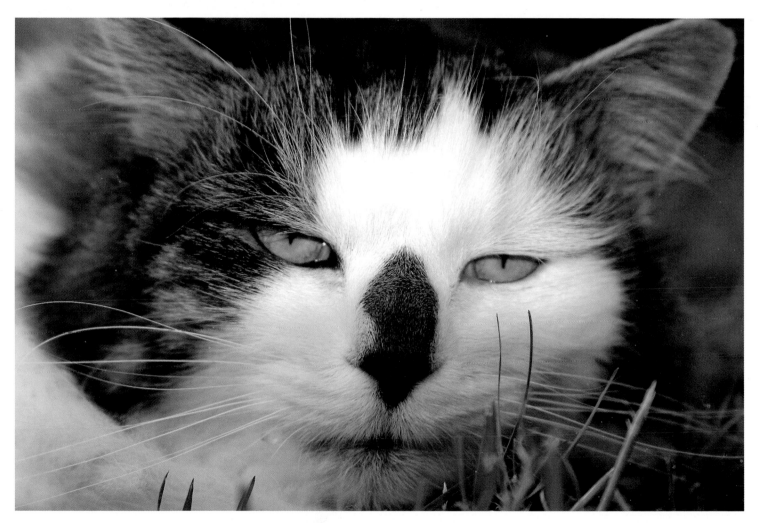

The dappled sunlight helps to make this a very intimate image. The cat was dozing under a lavender bush and was quite relaxed despite the hoards of bumblebees buzzing overhead. A low angle of view and a zoom lens allowed the cat's face and eyes to fill the frame.
Domestic long-haired tabby cat
Canon D30, 28–135mm lens at the 100mm end

Small Pets

The overall consideration when photographing small pets is to ensure that they are safe from predators and cannot escape. There are a number of ways to prevent escapees disappearing into the undergrowth, the easiest and cheapest of which is to use a willing handler. As most rabbits, guinea pigs and ferrets are owned by children, it may be a good idea to get the youngsters involved, providing they understand that they must handle the animal with care. This can also be a good opportunity to grab some informal interaction shots between the pet and its owner. Gerbils, mice and rats should not be photographed outside for obvious reasons – it is easier and safer to photograph them in a controlled environment.

A simple and relatively cheap way to control small creatures is to make a barrier from clear acrylic sheeting, which can be bought from most DIY stores. Cut the sheet into four suitable lengths of sufficient height to prevent the animal from climbing or jumping over. Tape the joints together to make a square frame and cut the front section in half, so that you can place the camera lens through a clear area. Wire mesh can be used, but this can cause problems by showing up in the background. By using a small aperture, however, the mesh can be thrown sufficiently out-of-focus so that it does not register on the picture.

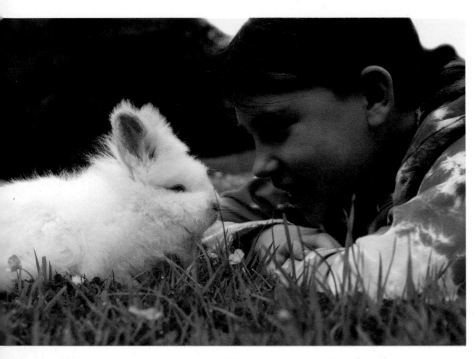

Many small pets belong to children and during a photo session they can be very useful as handlers. Keep an eye out for those unplanned informal moments as they will sometimes make the best photographs.
Angora rabbit and owner
Canon D30, 28–135mm lens at the 28mm end

A simple barrier can be made out of clear acrylic sheeting. This will contain your pet and will not show up in the background, especially if a large (f/2.8) aperture is used.

Acrylic barrier with taped edges

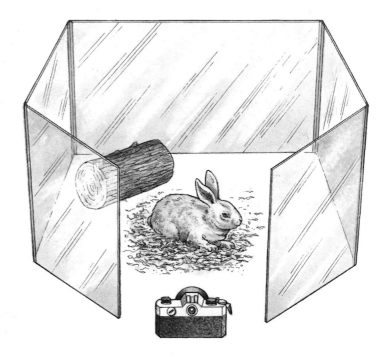

HOW TO TAKE THE PICTURE

Whether you are taking photographs of a Great Dane, a Persian cat, or a lop-eared rabbit, there is one all-important rule: get down to the animal's eye-line and, in the case of small creatures, this may mean spending time lying flat on your stomach. The very action of crouching, or lying down can cause varying reactions in different animals.

From an early age dogs are encouraged to come to their owners when they crouch down – it is instinctive. To avoid ending up with an album full of blurred pictures you will need to employ some basic dog-training techniques.
English springer spaniel
Canon D30, 28–135mm lens

Dogs

When greeting our canine companions, we instinctively bend or crouch down to stroke the animal. Over time, the dog associates this action with a pleasant moment of interaction with the human. Crouch down and most dogs will come running up to you. This reaction can cause problems when trying to take photographs and, if you are not careful, you may end up with a very out-of-focus picture, as well as a very large dog sitting on your lap slobbering over the camera.

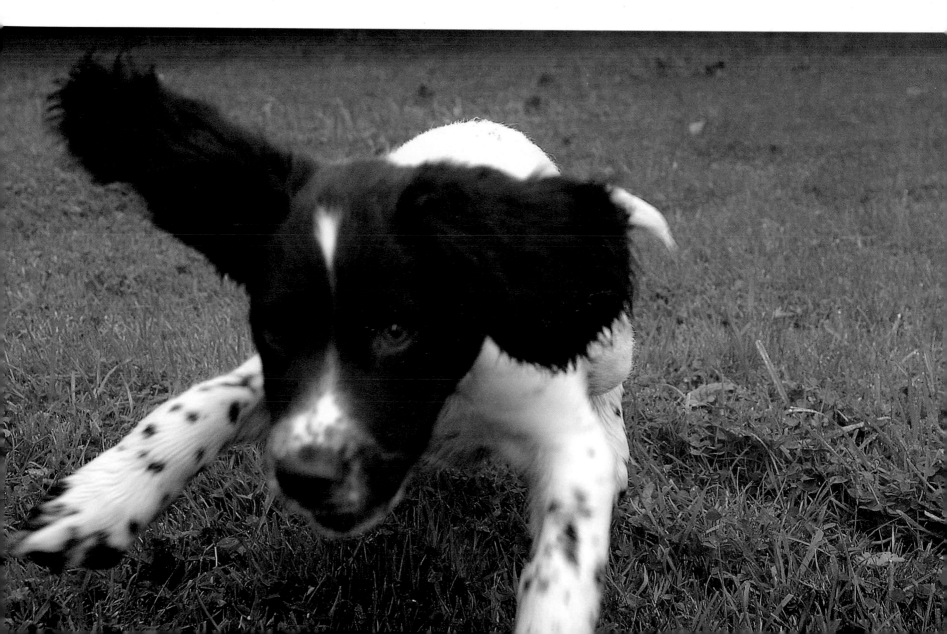

Most owners teach their dogs to 'sit' and to 'stay' and this can be used to our benefit. Once the dog is in a suitable position, it is helpful if either you or the owner gives the 'sit' or 'stay' command as you start to crouch down to the dog's eye level. This needs to be re-enforced at times during the picture-taking.

An additional point to bear in mind when photographing dogs is that they will usually associate being outside with playtime, so it is worthwhile letting the dog run off some steam before attempting to take the photographs.

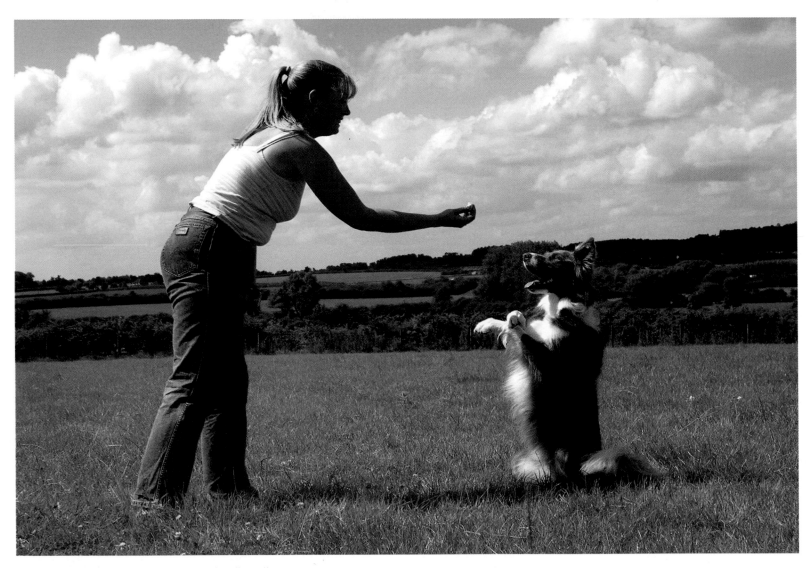

A well-trained animal and a competent handler will make taking photographs very easy indeed.
Red Border collie and owner
Canon D30, 28–135mm lens

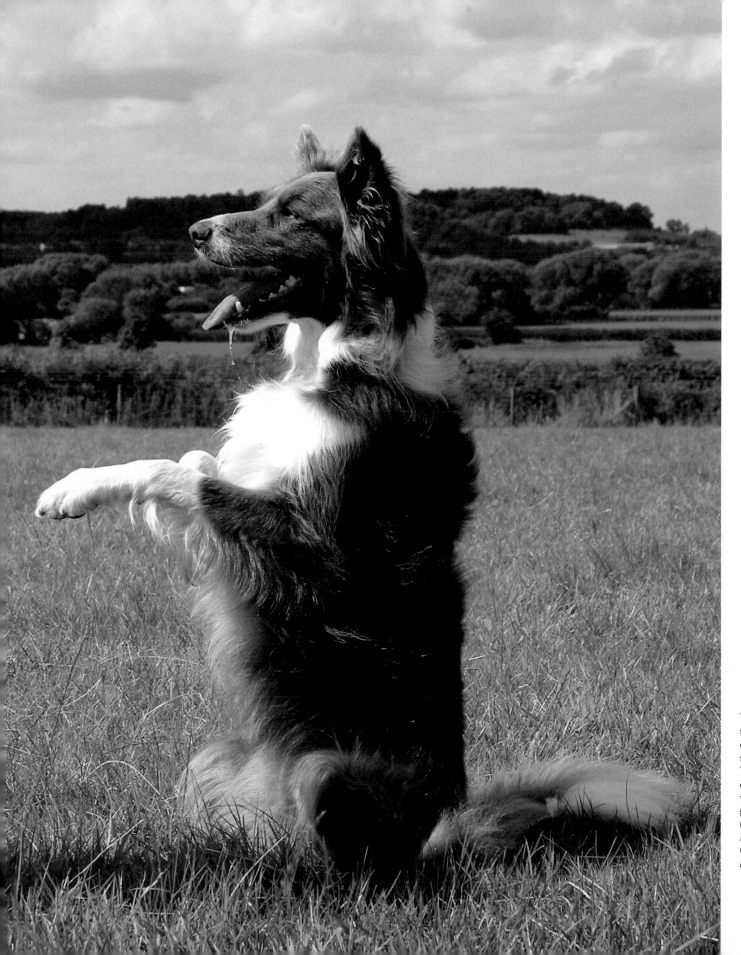

The resulting picture shows off the dog's character along with some stunning scenery. The colour of the dog's coat contrasts nicely with the green of the grass and the blue of the sky.
Red Border collie
Canon D30, 28–135mm lens

Most owners teach their dogs basic commands such as 'sit' and 'stay'. Re-enforce these instructions as you bend down to take the picture.
English springer spaniel
Canon D30, 28–135mm lens

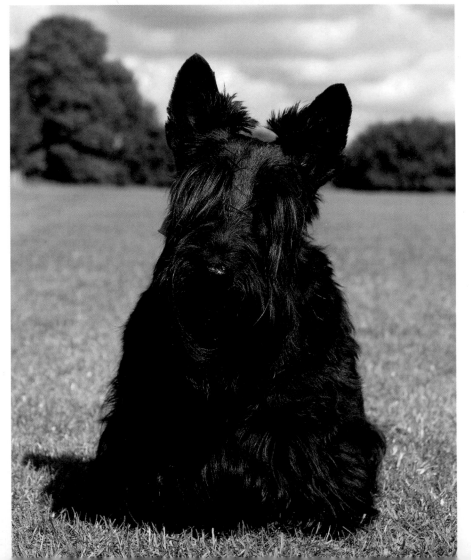

If the dog is in a sitting position it is less likely to get up and run towards you, so ask the owner to give the 'stay' command as you get into position to take the photo.
Scottish terrier
Canon D30, 28–135mm lens

Cats

Our feline friends demand a rather different approach when being photographed outside. While, in most cases, the dog will be static and allow you to command some kind of control over it, you have to adopt a 'stalking' approach with cats. This calls for quick reactions and plenty of patience. If the cat belongs to you, then you will have an intimate knowledge of its favourite dozing places and any trees that it likes to climb. These are all good places to take informal relaxed pictures.

You shouldn't have so much of a problem with cats running up to you when you lie down at their eye level. If that does happen, then there is not much you can do but get up and start over again. When photographing pets, you will need as much patience as camera film.

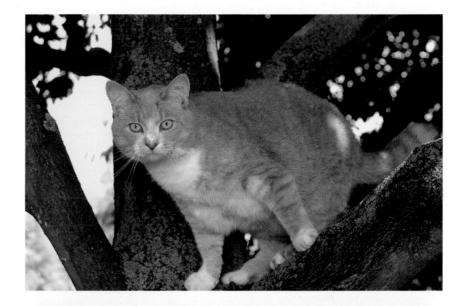

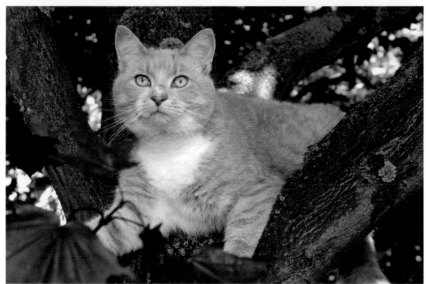

The best way to photograph cats outside is to adopt a 'stalk and shoot' technique. This calls for quick reactions, a good dose of luck and plenty of patience. This cat's owner put it in the tree, and a number of unsuccessful images were taken before the cat settled down.
Domestic short-haired cat
Canon D30, 28–135mm lens at the 135 end, 550 EX flash

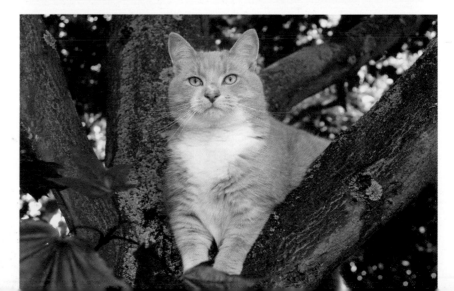

Small Pets

The main problem when photographing small furry pets such as guinea pigs, rabbits and ferrets, is that they tend to move around quite quickly and, when you are lying flat out, it can be difficult to keep up with them. They should always be contained within a barrier, perhaps using food as a handy tool to keep them in one place. Try sprinkling some rabbit or guinea pig food in the grass and, hopefully, this will keep them happy long enough to take some pictures. It is better to try to get pictures of rabbits doing something like standing on their back legs, or cleaning themselves. Guinea pigs tend to be a little more sedate so pick your moment if you want something more than just a standard shot.

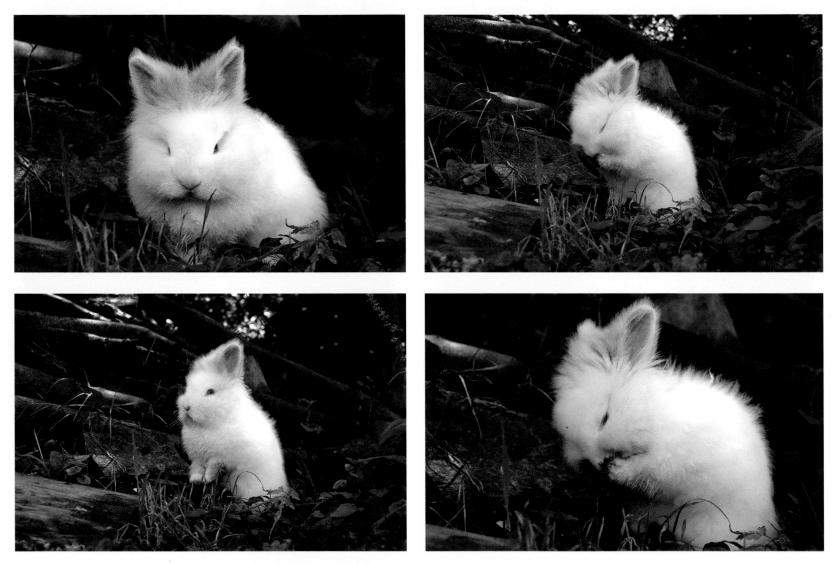

Rabbits have a habit of standing on their back legs to clean themselves. Be patient, and you may be rewarded with the opportunity to take a series of photographs that will definitely have the cute factor.
Angora rabbit
Canon D30, 28–135mm lens at the 135 end, 550 EX flash

Ferrets offer the pet photographer a multitude of challenges, not least because they will test your patience to the end. They are constantly on the move and extremely inquisitive. Point a camera at them and the chances are that they will run over to investigate. A good trick is to put a log in the pen and smear some dog food where it cannot be seen. If you are lucky, this will keep the ferret amused long enough for you to get a few frames of film exposed. If you are feeling fit, and have an experienced handler available, you could try taking pictures as the ferret explores the garden, but remember that ferrets are first class escapees, so make sure the area is secure.

Ferrets are fast and inquisitive and a constant challenge to the pet photographer. Always have an experienced handler to help you, as trying to control a camera and a ferret is definitely not for the faint-hearted.
Polecat ferret
Canon D30, 28–135mm lens at the 135 end, 550 EX flash

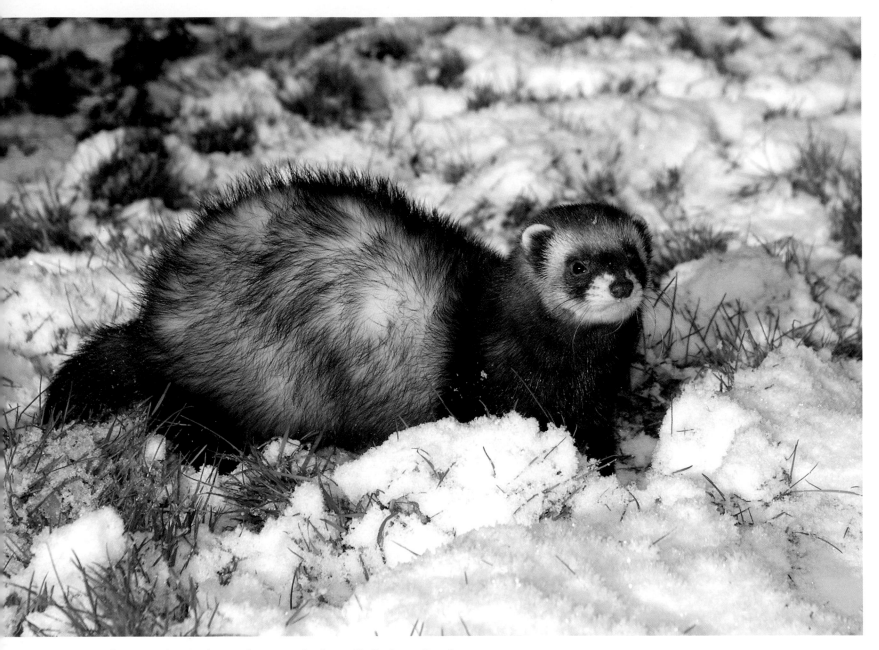

In this picture the snow has acted as a natural reflector. Ideally the eye-line of this photograph should have been lower, but there are limits, even for the most ambitious pet photographer.
Polecat ferret
Canon D30, 28–135mm lens at the 135 end, 550 EX flash

COMPOSITION AND LIGHT

Composition and light are the two natural elements that can make an ordinary photograph into something special, and photographers are always in pursuit of the perfect combination. If you were a landscape photographer, you might spend many hours on a hillside waiting for a shaft of sunlight to illuminate a rundown shepherd's hut nestling among a sea of bracken. As a pet photographer, you have to think on your feet (or stomach) and act quickly and impulsively. However, subject matter is no excuse for sloppy technique and you do have some control over how the picture is composed using natural or artificial light to your benefit.

Composition

You can have the most stunning light, the most beautiful and well-posed pet but, if the composition is wrong, you will end up with nothing more than an ordinary picture. When composing an image of your pet, some pre-planning is time well spent. Decide whether you want to show the animal in close-up, in its own environment, or in one that will complement its breed.

A frame-filling close up of your pet can be a good way of portraying its personality. Remember to focus on the eyes and let the body fill the rest of the picture.
English springer spaniel
Canon D30, 28–135mm lens

Most people will automatically frame a photograph with the main subject placed in the centre of the camera viewfinder and the animal looking straight at the lens. Changing the angle of view, and putting the subject slightly off centre, can dramatically change the way a picture looks.

There is a common rule in photography known as 'The Rule of Thirds'. Imagine a grid placed over your picture consisting of two vertical lines and two horizontal lines. If you were to place the main focus of your subject (the animal's head/eyes) on one of the intersecting lines, this would generally produce the most pleasing image. If you take this method one step further and remember that, in most cases, we focus on the animal's head, this technique will enable you to fill the frame with part of the subject's body without a huge expanse of extraneous background.

Dogs look better if they are positioned either side-on, or at a slight angle: if they look straight at the camera, it can flatten the profile of their face.
Red Border collie
Canon D30, 28–135mm lens

The eyes are the main point of focus in this image and they are positioned towards the top third of the photograph, allowing the rest of the cat's body to fill the lower part of the frame.
Domestic long-haired tabby cat
Canon D30, 28–135mm lens at the 100mm end, 550 EX flash

There is a choice of two main formats: landscape or portrait. By holding the camera in its normal horizontal position, you can produce images in the landscape format. By turning it on its side, in the vertical position, you can produce images in the portrait format. Both methods have their place in pet photography, but will produce totally different viewpoints.

The majority of cameras have a focusing point in the centre of the viewfinder, while some advanced models can have anything up to 45 focusing points. If your camera has only one centre point, it is worth checking your manual to see if you have a 'focus-lock' facility. Focusing on the subject, then holding the shutter button halfway down, normally operates this function, which will allow you to recompose the picture, but keep the lens focused on the original point.

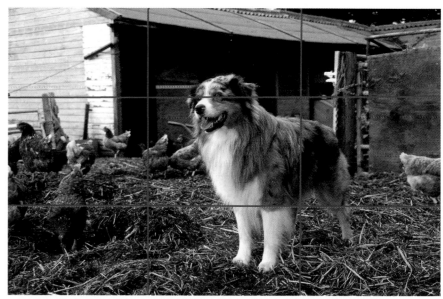

'The Rule of Thirds' is a good compositional rule to remember when taking any photograph. Rather than putting the main subject in the middle of the image put it slightly off centre. In this instance it allows space to the left of the dog for it to 'look' into the picture.
Australian shepherd
Canon D30, 28–135mm lens at the 28mm end. 550 EX flash

If you turn the camera into the portrait format and focus on the head of a sitting animal, you are likely to end up with a photograph showing half of your pet and the other half depicting a nondescript background. By moving the camera down and putting the head of the animal at the top of the frame, the result is far more pleasing and you will have a photograph where the animal fills the picture. The same applies when using the horizontal or landscape format. If the animal is lying with its head in the centre of the viewfinder, you will get a similar effect where only half of the photograph shows the animal. Compose the picture with your pet's head to one end

of the viewfinder and let the animal's body fill the frame. The result is an image that is more pleasing to the eye.

'The Rule of Thirds' can have other applications in pet photography, when trying to show the environment that the animal either lives in or that suits its breeding. A good technique is to frame the model in the viewfinder, off to one side, with the animal looking into the picture. This works extremely well when using settings to suggest that the pet is surveying its territory. Before taking a picture using this technique, always check the entire image in the viewfinder to make sure that you do not have distracting elements showing.

When taking pictures in the 'portrait' format be aware that you could end up with a substantial amount of extraneous background towards the top of the image if you use a centre focusing point. It is better to focus-lock the camera and then recompose the image.
Black Labrador retriever
Canon D30, 50mm lens

This image has been recomposed using the focus-lock technique. It shows a better composition and the subject fills the whole frame.
Black Labrador retriever
Canon D30, 50mm lens

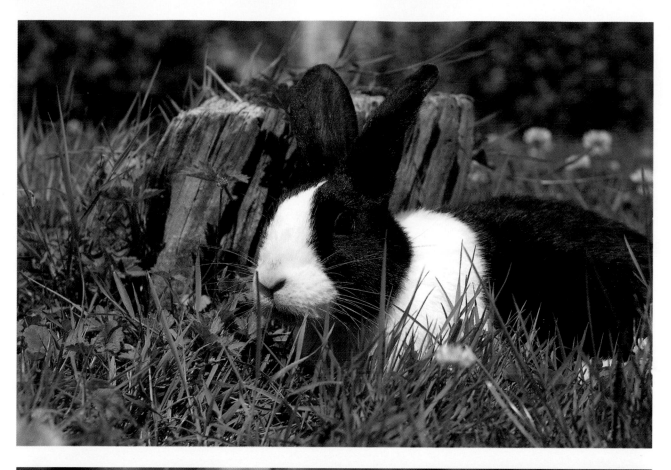

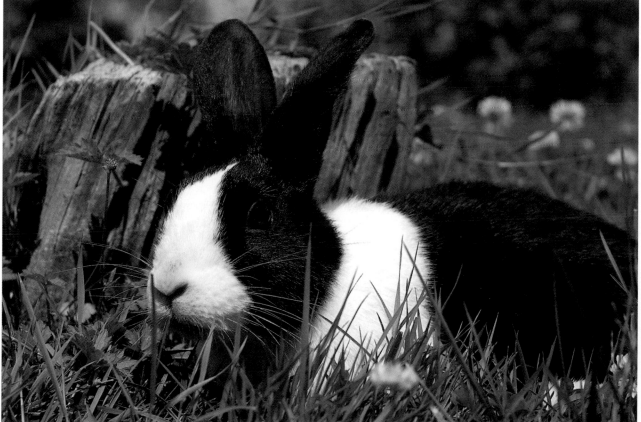

When photographing your pet using the horizontal or landscape format, the composition can be greatly improved if you move in closer and position the animal's head to one side of the frame.
Dutch rabbit
Canon D30,
28–135mm lens

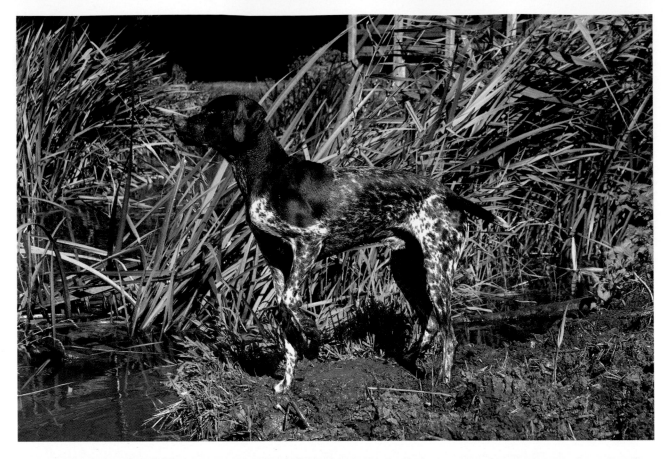

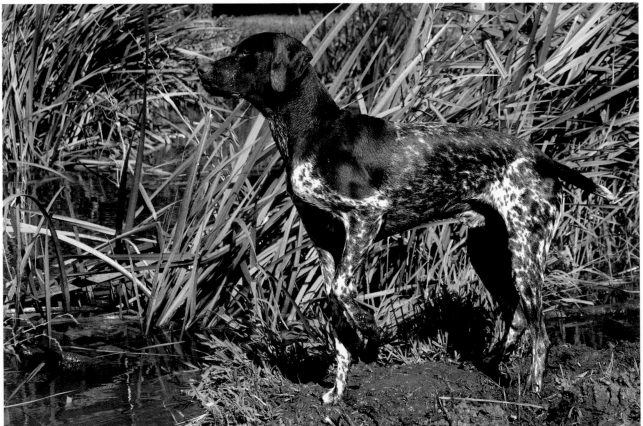

A good technique to use when photographing your pet outdoors is to position the animal to one side of the viewfinder with the animal looking into the image. This gives the impression that it is surveying its territory and makes for a more pleasing image. *German short-haired pointer Canon D30, 28–135mm lens*

Lighting

When photographing pets outside, the main source of light will be the sun. As always, the direction of the light falling on the animal will have a major effect on the final appearance of the photograph. The most common advice given to photographers is that they should have the sun behind them, so that the light falls directly onto the subject. This is probably the safest position to choose but, in reality, it produces light that is flat and uninteresting. Pets are covered in either fur or hair and one aim of the photographer should be to show the form and texture of the animal's coat. You will not achieve this aim with frontal lighting. Instead, use either side or back lighting, depending on the effect you are trying to achieve.

Side lighting tends to produce the maximum amount of detail in the fur or hair and can give a strong impression of form and texture which is ideal for pet photographs. One problem caused by this style of lighting is that the side in shadow can lose detail and, in a dark-coloured animal, this will not look right. However, you can compensate for this by using either your flashgun to add some light into the shadow areas, or a reflector (a large piece of white paper will suffice). The reflector should be held by an assistant on the opposite side to the light and, by simply moving the reflector nearer and further away from the subject, you can vary the strength of the reflected light.

Frontal (diffused) lighting has enhanced the texture of the fur and put an all-important highlight in this rabbit's eye. The sunlight was diffused through the canopy of the trees and this has created the highlights and shadows across the coat.
Netherland dwarf rabbit
Canon D30, 28–135mm lens, f/5.6

Front lighting

Side lighting

Back lighting

The direction of the sunlight has a significant influence on the final image and each angle requires a different technique to succeed.

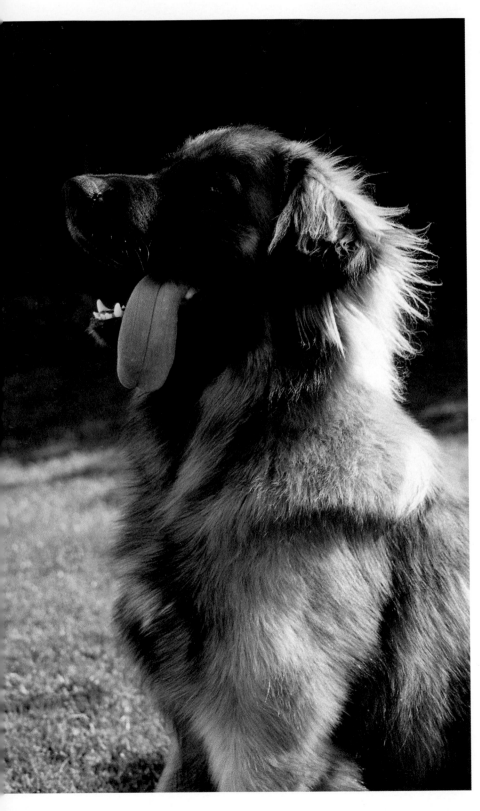

Back lighting is the most difficult type of lighting to judge properly. When it works well, the outline of the animal will have a lovely rim of light, which can look as though the fur is glowing. This is particularly effective when a light-coloured animal is photographed against a dark-coloured background. The downside of this type of lighting is that the front of the animal will be in shadow and, once again, you may lose all detail in its face and head. Use the flashgun to lift the shadow or, once again, try the reflector. If your camera has a spot-metering function, use this to take a reading from the shadow area and manually set the exposure. This will help prevent the subject being shown as a silhouette.

Back lighting creates a glow around the edge of the animal, especially if it is photographed against a dark background. You may need to use a reflector or some fill-in flash to prevent the shadow side being too dark.
Leonberger
Canon D30, 28–135mm lens, reflector

FLASHLIGHT

Many people consider using flashlight only when there is no natural daylight to expose their photographs, but the humble flashgun can be just as useful during the sunniest of days.

All natural or artificial light creates shadows and highlights and the difference between these is known as contrast. If you have too much contrast, the shadow areas will be too dark and show no detail, or the highlights will be burnt out and the detail will be lost. This can be a particular problem if the sun is coming from behind or to one side of the subject.

Most flashguns are either built into the camera, or are attached to the camera via a hot shoe, and the amount of light they produce is controlled by a mini computer inside the camera body. If left on automatic, the flash will produce just enough light to lift the detail in the shadow areas and reduce the contrast, a technique known as fill-in flash. Do not worry about the flashgun spoiling the effect of your side or back lighting; the light produced will not adversely affect the sunlight as it is not as strong and is only present for a very short period of time.

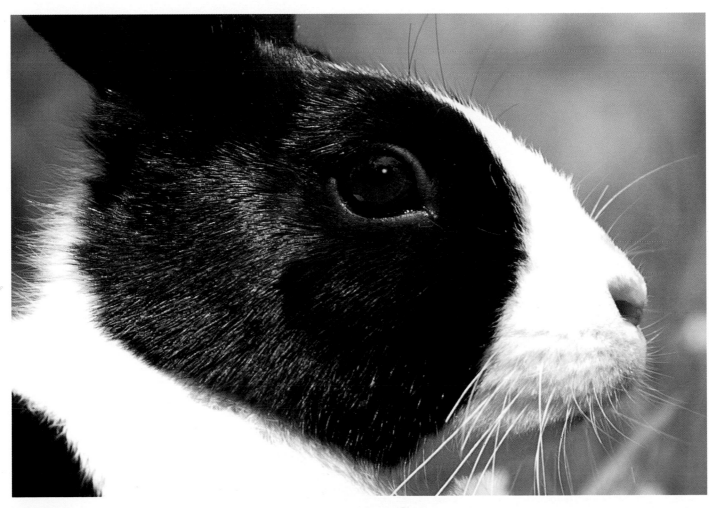

One advantage of using flash during daylight is that you can put that all-important catch-light in the animal's eye – without it the eye can look dark and lifeless.
Dutch rabbit
Canon D30, 28–135mm lens, 550 EX fill-in flash

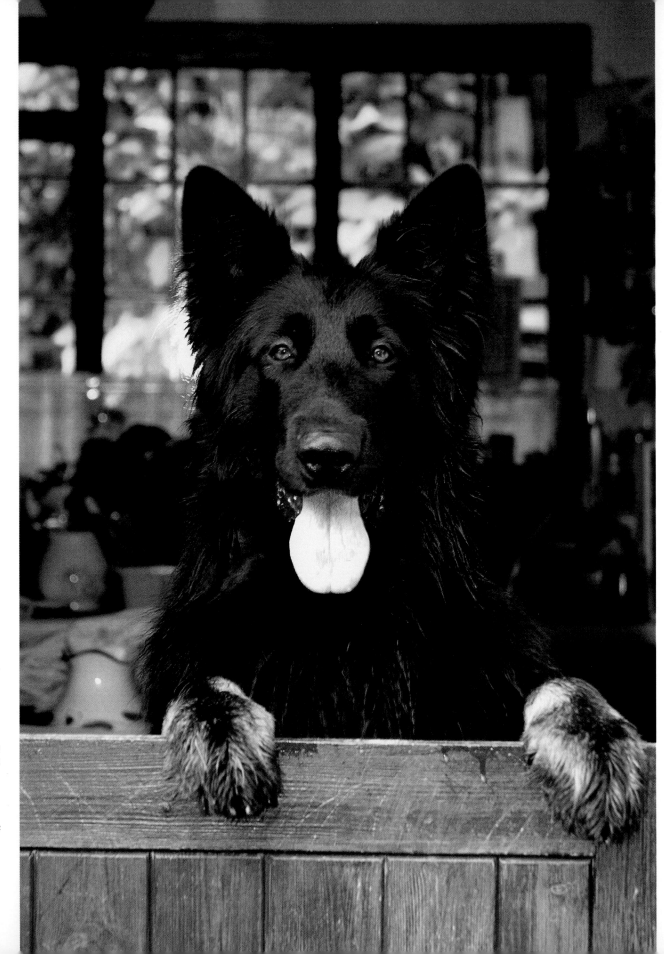

Although you cannot get your pet to smile on command you can capture its personality through the expression of its eyes, ears, nose and body shape. It also helps if you have nerves of steel, especially when photographing huge black German shepherds.
German shepherd Canon D30, 28–135mm lens

TECHNIQUE

Once you have chosen the location and decided on the direction of the light, it is time to get the camera out and start taking pictures. Unlike human models, animals cannot be asked to smile or look at the camera so patience, verbal direction and watchful waiting for the animal to assume the required pose are the only option.

Expressions in dogs and cats are the result of four elements: eyes, ears, nose and body shape. Eyes should always be the point of focus. An animal's eye can sometimes look dark and lifeless but, by using the flashgun, reflector or natural sunlight, you will put a small catch-light in the pupil of the eye, giving the animal that all-important alert expression.

Next are ears. They should always be 'up'; even dogs with long, droopy ears can prick them up. This helps to change the shape of the head and once again gives the animal a happy, alert pose. And how many times have you been told that a wet nose is the sign of a healthy animal? As well as ensuring that the nose is in focus, you can make it shine by a careful choice of lighting.

Ears are a very important and characteristic part of any pet. It is best to try and get them 'pricked up' by using your repertoire of whistles and squeaks. But, sometimes, no matter how hard you try, you will just not succeed.
Border collie
Canon D30, 28–135mm lens

Body shape is very important. It is not easy to pose an animal (unless it is a show dog or cat) but you should be able to place it into a suitable posture. If you plan to take full-length shots, then dogs certainly look better standing or lying down. When they sit, some dogs have a habit of slouching and this is not a flattering pose. If you are going to take head and chest pictures, then it may be appropriate to get the animal to sit. Position the animal side-on or three-quarters onto the camera and try to avoid having the animal facing directly towards you as this can flatten the profile of the animal's face.

If the dog is sitting, take the picture from side-on with the head and shoulders leading out of the bottom of the frame. This gives the impression that the dog is looking into the picture and shows the profile of the head, muzzle and ears.

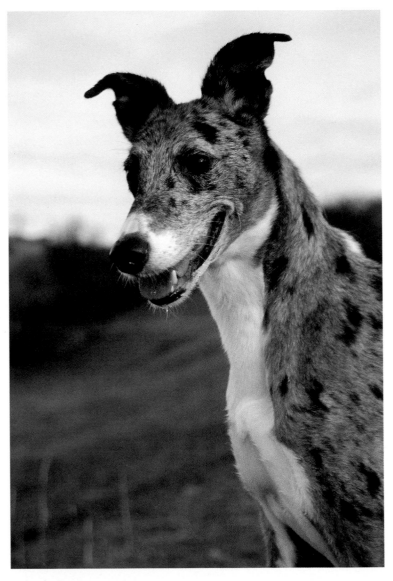

Collie x greyhound lurcher
Canon D30, 28–135mm lens

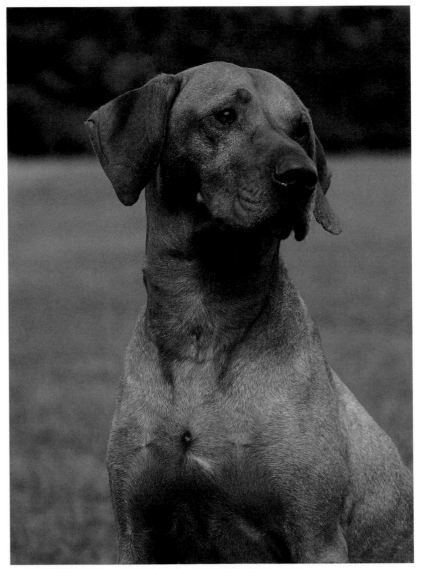

Hungarian vizsla
Canon D30, 28–135mm lens

There are numerous tricks to be employed in an effort to get that classic cocked-head shot that can look so appealing. Squeakers from old dog toys can be very effective, as they are quite small and so do not get in the way of the camera. Most dogs find the noise irresistible and will tilt their heads trying to work out where the noise is coming from. You will build up quite a repertoire of clicks and hisses all of which will work, but do try to avoid using the animal's name or whistling, as the resulting pictures will be a very out-of-focus image just before the animal leaps onto your lap.

Even the best laid plans do not always work and expression and form go right out of the window. Never mind, it still makes for an amusing photograph.
Domestic short-haired cat
Canon D30, 28–135mm lens at the 135 end, 550 EX flash

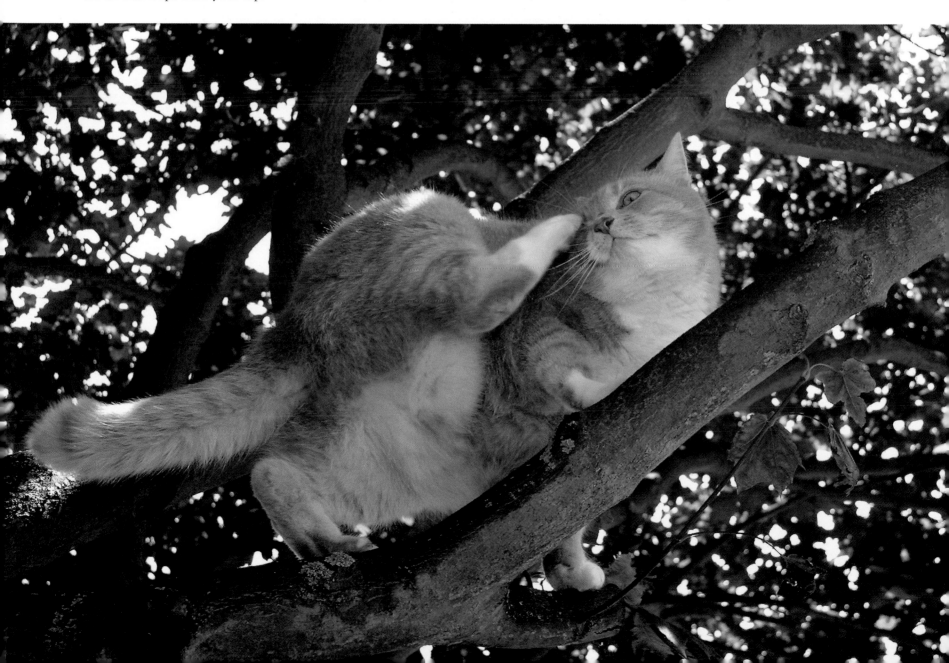

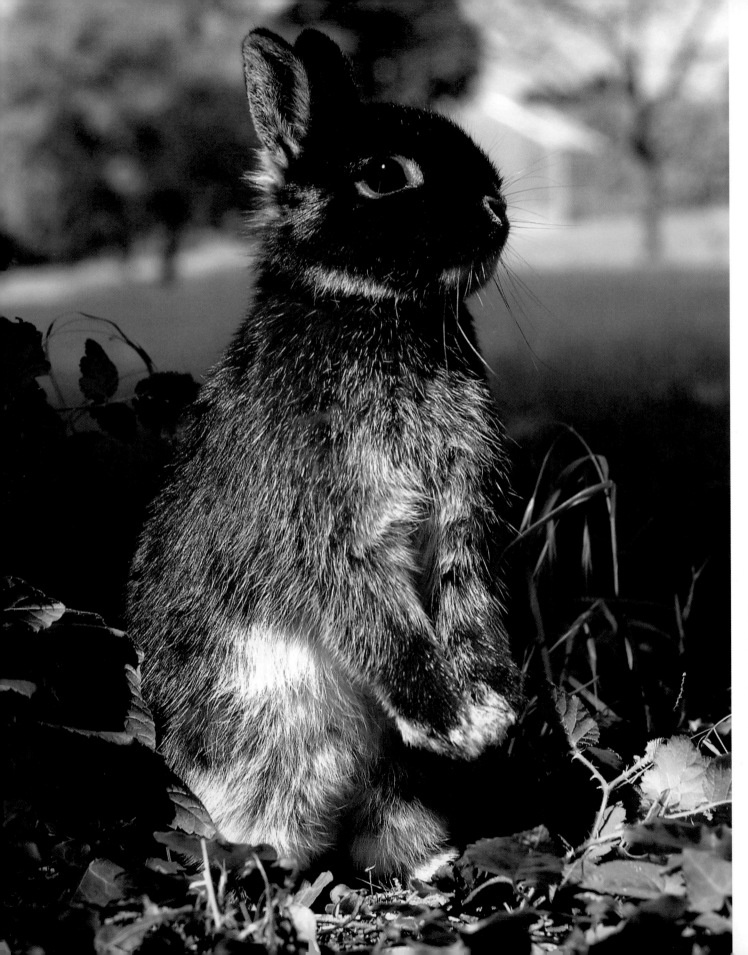

Put a rabbit in an unusual environment and it will instinctively stand on its back legs to survey its new surroundings – this is the time to start taking pictures. This rabbit was photographed in a back garden using dappled light that was filtering through a tree. An aperture of f/2.8 has thrown the background out of focus.
Netherland dwarf rabbit Canon D30, 90mm macro lens, f/2.8

Cats require a slightly different approach, as they will do what they want when they want. There are numerous cat toys on the market and the best for photographic purposes are those with a toy on the end of a wand. These are great for provoking a swiping paw from an otherwise sedate model. You will need lots of patience for smaller creatures, such as guinea pigs and rabbits. It is really a case of waiting until the animal performs some natural and interesting act, such as cleaning its ears or standing up, before taking the picture.

Food treats can be an invaluable tool but, be warned, do not overdo them. Nearly all of the techniques will be better used by a handler or a willing owner, as this will allow you, as the photographer, to concentrate on getting the composition right and being ready to press the shutter button when the animal demonstrates that perfect pose.

SUMMARY – TOP TIPS

◆

PRE-PLANNING YOUR PHOTO SESSION IS
TIME WELL SPENT

◆

FOR 'SAFE' LIGHTING THE DIRECTION OF THE SUN
SHOULD COME FROM BEHIND THE PHOTOGRAPHER

◆

FOR A MORE INTERESTING LIGHT, TRY PLACING
THE SUN BEHIND, OR TO ONE SIDE OF
THE ANIMAL

◆

USE FILL-IN FLASH OR A REFLECTOR TO
LIGHTEN SHADOWS

◆

UTILIZE A WILLING HANDLER OR OWNER TO
ATTRACT THE ANIMAL'S ATTENTION WHILE
YOU CONCENTRATE ON THE COMPOSITION
OF THE PICTURE

◆

IF THE ANIMAL IS SHOWING SIGNS OF STRESS
OR BOREDOM, PUT THE CAMERA AWAY AND
TRY ANOTHER DAY

Chapter 4

Indoor/Studio Portraits

The biggest advantage of indoor portraits is that, no matter what the weather is doing, you can still get your camera out and take pictures of your favourite subject. Pets share our homes, so what better place to take photographs than in the relaxed comfort of the living room? Cats and dogs will have their favourite places, ranging from a simple wooden box to the luxury of a three-piece suite – either of these would make a suitable background, while old barns or sheds can offer the perfect setting to take interesting and visually diverse images, providing a bit of forethought goes into the arrangements.

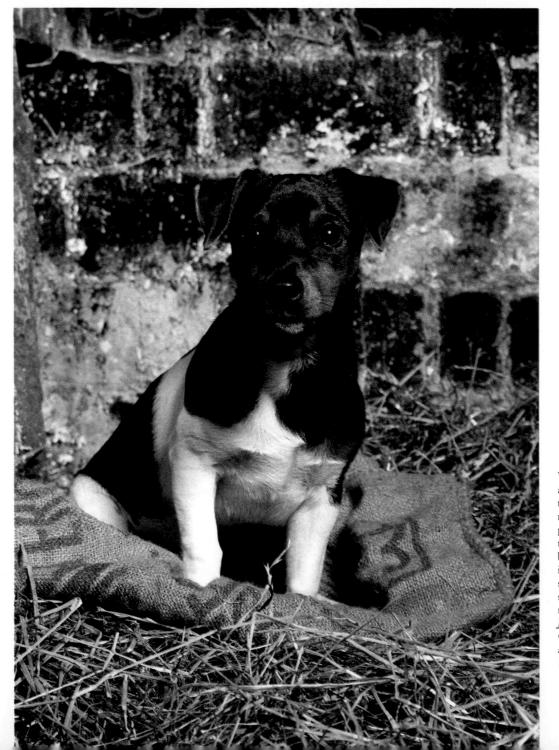

Working dogs such as this Jack Russell terrier puppy look right at home when photographed against the backdrop of an old brick shed. The introduction of some straw and a piece of sacking enhances the rural theme.
Jack Russell terrier Canon D30, 50mm lens, studio flash units, 1/60sec at f/11

The safety of indoors can also be used to take portraits of smaller pets such as hamsters, gerbils and even reptiles. With these smaller creatures you can let your imagination run wild and create mini-sets in a bid to make it appear that the animal is in a more interesting and natural environment.

Lighting indoor portraits is a totally different matter from lighting portraits taken outside as, in most cases, you will need to use artificial lights, such as flash units. However, natural daylight can still be used, especially if there are any large windows or patio doors available.

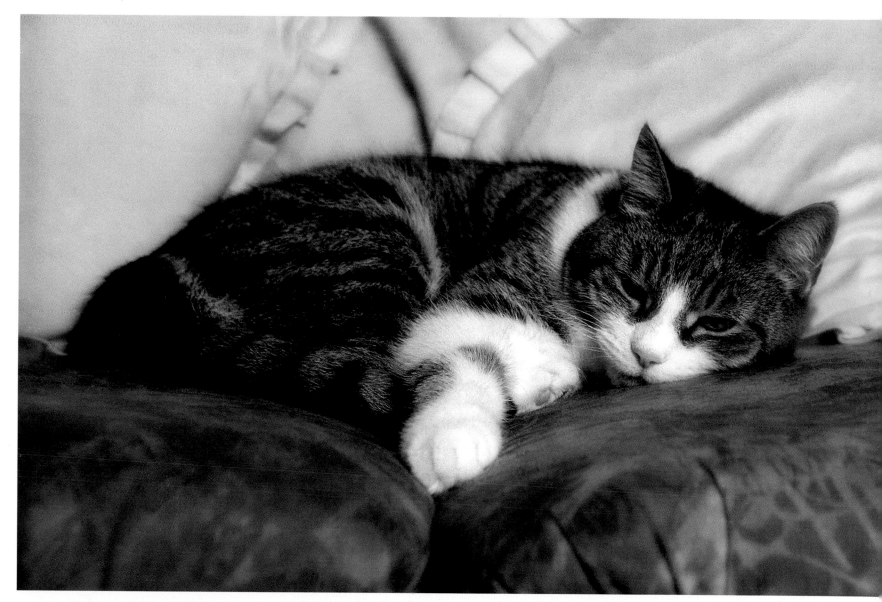

No matter what the weather, you can utilize the comfort and safety of your own home to take formal or informal portraits of your pets. The backdrop can be as simple as the family sofa using available daylight, or as complicated as a portable studio with monobloc flash units.
Domestic short-haired tabby cat
Canon D30, 28–135mm lens on camera flash with soft-focus filter

BACKGROUNDS AND BACKDROPS

When deciding on suitable backgrounds or backdrops for use during an indoor photo session, there are basically three choices: existing or permanent, home-made, or manufactured. The choice for the majority of inexperienced pet photographers will be existing furnishings and, in some ways, these are the best to use as they add a personal touch to the pictures. Dogs and cats will quite often use sofas and armchairs, or may have their own seating arrangements, which can be an ideal backdrop for informal and character portraits. The modern trend for plain-coloured materials is perfect for photographs and, even if your pet favours a highly patterned chair, you can always throw an old blanket over it to tone it down.

If your pet has its own sofa, or is privileged enough to use the family's, this can be a good prop.
Mongrel
Canon D30, 50mm lens, two studio flash units

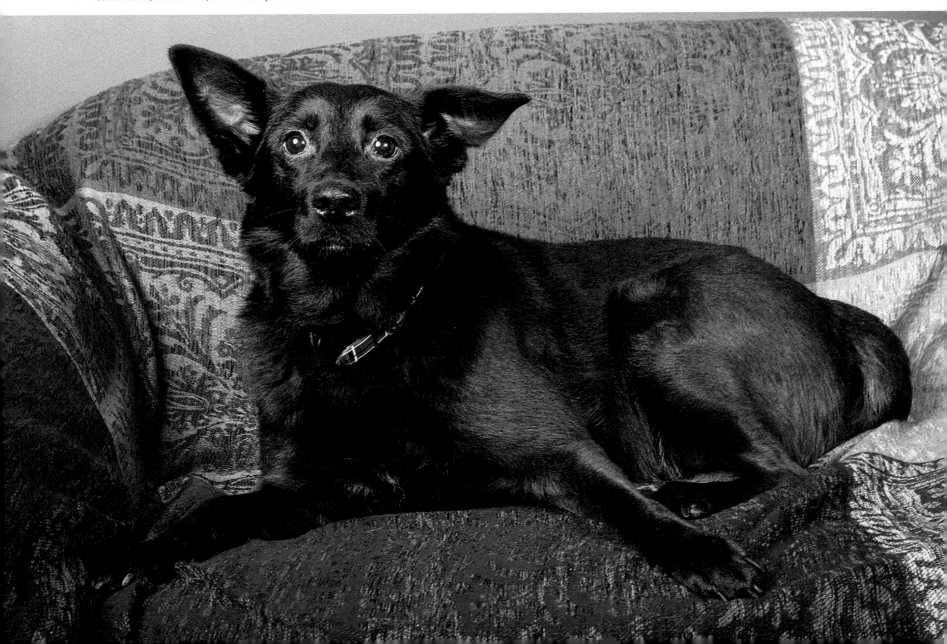

When taking photographs of animals in armchairs or on sofas, try to exclude as much of the extraneous background as you can, as this will help to keep the backdrop neutral and uncluttered. However, as with all photography, rules are made to be broken and, on occasions, it may well be better to show the complete setting, especially if you really want to personalize the photograph.

Home-made backdrops can be created from a variety of materials, ranging from old sheets and blankets to curtains. In general, if you are going to make your own backdrop, it will need some kind of pattern or tone to avoid it appearing quite stark. If you are intending to use an old sheet, it is advisable to start with a light one and either dye it to achieve a mottled effect, or try painting it with propriety vehicle spray paint or, if you can find it, fabric spray dye. Take a look at some manufactured backdrops, as these will give you an idea of how to create the right effect.

A word of warning: if you do decide to spray-paint a backdrop, then be sure to do it in a well-ventilated area and observe the instructions on the can.

Cats are often more relaxed and at ease when sitting or lying in the comfort of their own beds. Use a zoom lens to get in close and fill the frame. Because this cat is not looking directly at the camera, the image gives the impression that it is deep in its own thoughts.
Persian cat
Canon D30, 28–135mm lens at the 135 end, two studio flash units

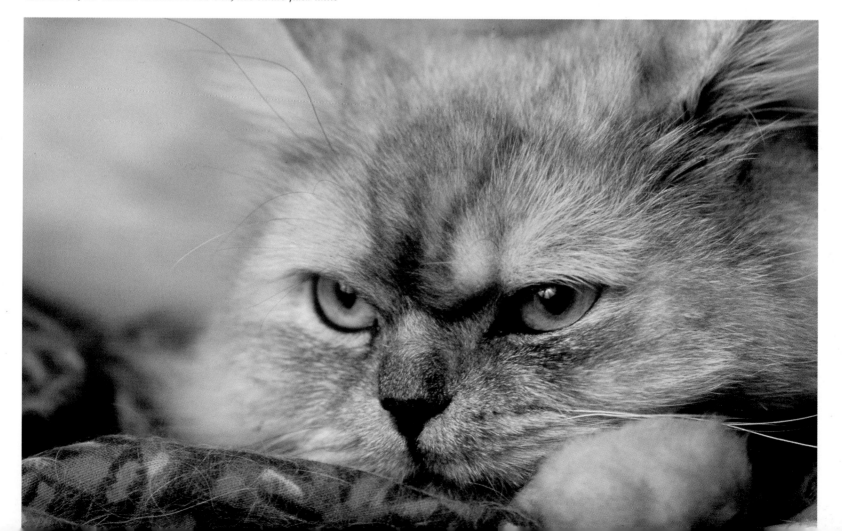

Offcuts of material can be very useful, particularly lengths of black velvet, which has a wonderful way of bringing out the texture of long-haired animals, especially cats. Obviously, though, a black animal should not be photographed in front of a black background, unless you want to highlight a pair of brightly coloured eyes.

If you can source a suitably coloured length of curtain material, this can also be pressed into use, especially if used as a backdrop or laid over the floor (perfect for dogs that want to have their pictures taken lying down).

With a bit of imagination, the interior of a humble garden shed can be an ideal place to use as a backdrop. Many sheds are manufactured from rough timber, which can give a warm, rustic look to the photographs, especially if you use some hay or straw on the floor to further enhance the effect. If you live in a rural area, you may be lucky enough to gain access to an old barn for a couple of hours but, if you are photographing a dog, do make sure that it is safe around livestock. Permission can be hard to get but is very easy to lose.

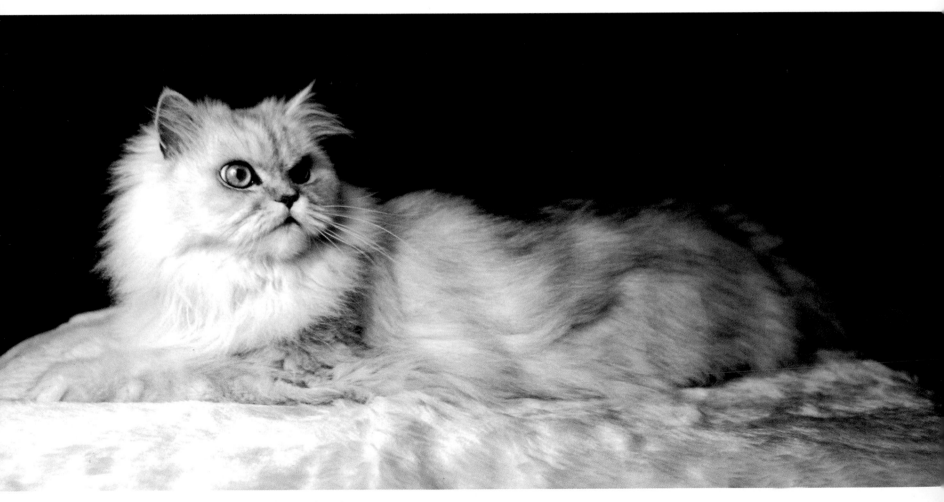

Backdrops can be made from offcuts of material. In this case, black velvet is excellent for showing off the texture of the cat's fur.
Persian cat
Canon D30, 28–135mm lens, one studio flash unit

With a bit of imagination the humble garden shed can be the perfect background for taking those 'extra special' portraits. Here, a timber wall, some straw, an old piece of log and a waxed coat add interest and shape to the set.
Canon D30, 50mm lens, one studio flash unit

A good photographer will be able to 'see' the picture long before the shutter button is pressed and will know what elements to put in place to make a successful portrait. Here, the log serves two purposes: it adds some interest, but also ...
Canon D30, 50mm lens, one studio flash unit

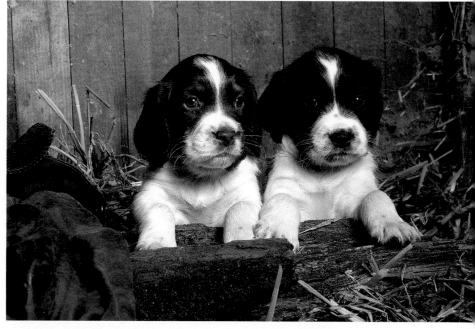

... it helped to stop these two very energetic puppies from running towards the camera when I lay down to take the picture. It certainly helps to know how your subject will react in any given circumstance.
English springer spaniels
Canon D30, 50mm lens, one studio flash unit

Another alternative is an ex-army camouflage net, which can be purchased from army surplus stores. There are a number of different patterns available and the best are those with a mixture of greens and fawns. Although they tend to be very drab in colour, if a suitable aperture is used to throw them out of focus they can be useful for creating a mottled, woodland effect. Camouflage nets are especially effective when used with props such as straw bales, a pair of old wellington boots and a crumpled wax coat (see picture below).

If you are really serious about pet photography, then the best option is to purchase a manufactured backdrop system. There are two basic designs. The first uses a system of vertical poles that stretch from floor to ceiling; a horizontal pole is strung between these and a printed canvas is then attached to this. The biggest advantage of this system is that there is little restriction on the height and width of the canvas. However, that is rarely a consideration in pet photography so this type of system is better suited to a studio that is permanently set up.

The props create a rural feel, while an ex-army camouflage net fills the gaps in the background.
Cross-bred collie
Canon D30, 28–135mm lens at the 28mm end, 550 EX flash

My preferred system is a printed canvas (normally manufactured from cotton) that is attached to a sprung frame. When opened, this is approximately 2.1 x 1.5m (7 x 5ft) in size and you can even buy these with long trains that extend to the floor. There are numerous advantages to this system, namely that they are quick to set up (they just lean against a wall), the canvas tends not to crease unduly and, when folded down, they are quite small and easily transported.

Manufactured backgrounds come in many different designs, ranging from general mottled effects to elaborate scenic views. Some companies will even print your own design (from a supplied image) onto a canvas. However, the golden rule with backdrops and backgrounds is that there are no rules. Use whatever you can, especially your imagination.

A manufactured background system that is portable and easy to set up. This model has the added advantage of having a train, which makes it ideal for taking portraits of animals that prefer to lie down.
Golden retriever
Canon D30, 28–135mm lens, 550 EX flash

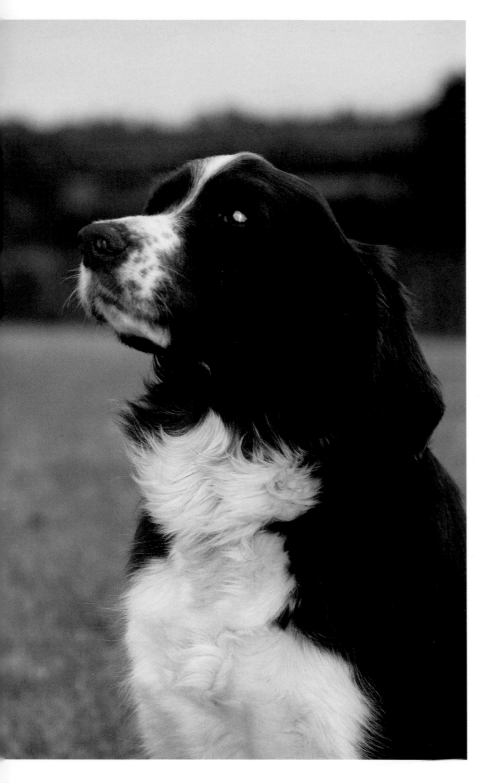

LIGHTING

Technically, lighting indoor studio portraits can be the proverbial nightmare, as unwanted shadows, the dreaded 'green eye' (see 'Artificial Lighting' below) and flash-shy animals will all cause you problems. However, if you follow a few simple rules and are prepared to experiment, you will be able to achieve a successful portrait.

Basically there are two options for lighting an indoor studio: artificial light (flash and tungsten) or natural daylight, providing there are suitably large windows available.

Artificial Lighting

The most convenient and easily accessible type of artificial lighting available to photographers is the versatile flashgun or unit. Nearly all consumer-specification cameras come with a built-in flash but, in most cases, these are not going to produce professional-looking portraits, no matter how hard you try.

The main problem with built-in flash units is that they are not very powerful and tend to be in the worst position to have a light source, because they are directly over the axis of the lens. This inevitably leads to strong shadows behind the subject and, in the case of animals, will quite often cause a phenomenon known as 'green eye' (called 'red eye' in humans).

One of the problems when using flashlight is a phenomenon known as 'green eye', which happens when the light is reflected from the back of the retina. In this case the situation was made worse, because the dog was elderly and had cataracts.
Cross-bred spaniel
Canon D30, 50mm lens, 550 EX flash

Green eye occurs when the light is reflected from the back of the eye (retina). In animals, this manifests itself as a glowing green light that, at best, looks strange and at worst looks quite scary. The easiest way to prevent this from happening is to move the flash away from the top of the camera and position it to one side. To enable you to do this, your camera must be able to take an accessory flashgun.

There are a number of techniques that can be used to help prevent green eye.

Modifying Light

Whether you use a flashgun or a monobloc flash unit, you will need to modify the light source to prevent harsh shadows and deep contrasts. There are numerous pieces of kit available that can be attached to, or placed in front of, the flash source to help achieve a softer light. The most common are umbrellas and diffusers, or a convenient ceiling or wall.

Bounced Flash

The main reason to use bounced flash is that it gives much more flattering results and the shadows are greatly weakened. If you point your flashgun directly at your pet, the light produced will be very harsh and will cast dense shadows behind the subject. Providing your flashgun has a tilt/swivel head, you can bounce the light off a suitable ceiling or wall to soften the light fall, so any shadow that is cast is reduced and thrown downwards, or out of the picture frame, where it will be less noticeable.

For bounced flash to be really effective, you must use a white wall or ceiling, as a coloured surface will create a colour-cast that will spoil the photograph.

Direct flash

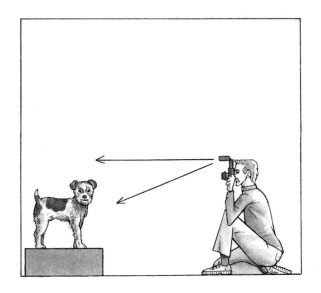

Flash bounced off white ceiling

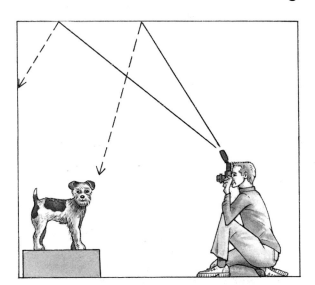

If your flashgun has a swivel or tilt head you can greatly improve your photographs by bouncing the light off a neutral-coloured wall or ceiling. The computers inside a dedicated unit will calculate the amount of light needed to correctly expose the film.

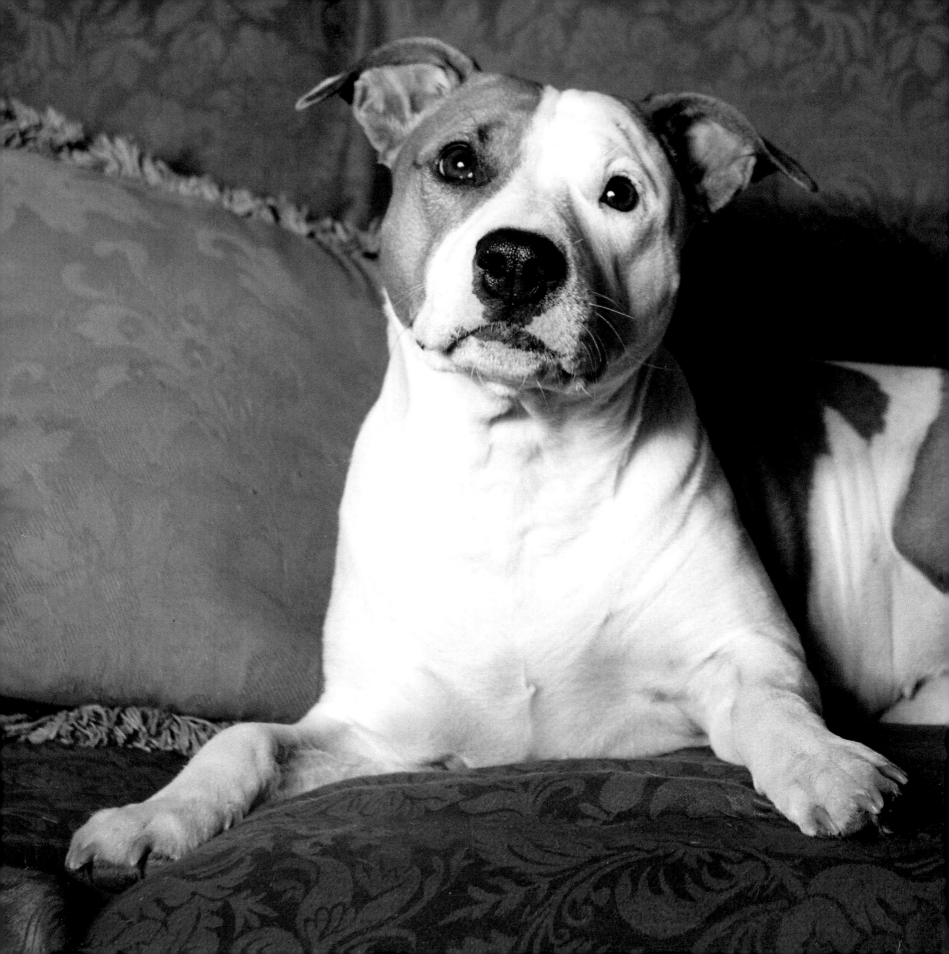

The technique of bounced flash is really quite easy. Simply tilt the head of the flashgun towards the ceiling at a 45° angle, so that it is aimed around halfway between you and the animal. If you are taking the picture in portrait (vertical) format, you will have also have to swivel the head of the flashgun. There is naturally some loss of light, due to the extra distance that the light will have to travel before reaching your pet but, if you use an automatic or dedicated flashgun, it will make up for this loss by increasing the light output.

A word of warning: if the wall or ceiling is too far away or too high, you will not be able to get sufficient light to bounce onto your pet so that it will be correctly exposed. If your flashgun has an exposure check lamp, it is worth making sure that it is illuminated after the picture has been taken. If it isn't, then you may need to move closer to your subject or try another method of diffusing the light output.

By using bounced flash green eye has been avoided and the shadows behind the dog have been softened considerably.
Staffordshire bull terrier
Canon D30, 28–135mm lens, 550 EX bounced flash

Diffusers

There are many different types of diffuser on the market, ranging from opaque plastic boxes to reflective sheets of card. Whatever the design, the aim is the same: to reduce and soften the light from the flashgun. A small plastic box that fits over the flashgun covering the light unit is the simplest – and one of the most effective – designs. The box is designed to be used with a tilt-and-swivel flashgun and should be used with the head pointing upwards in a 45° angle. This can be really useful when you want to bounce the flash, but the ceiling is too high to be effective.

Umbrellas

If you are using monobloc flash units, you will need some kind of light modifier, the most convenient of which is the flash umbrella. These come in two main designs: 'shoot through' and 'reflective'.

Shoot-through umbrellas are made from a translucent material and, basically, the light is fired through the umbrella.

The material reduces and spreads the light output, significantly softening any resulting shadows. On the other hand, reflective umbrellas have a silver, white or gold material on the inside face and the light is aimed into the umbrella and then reflected back onto the animal. The light will take on different qualities, depending on the colour of the material: silver gives a very sharp and defined light that is good for enhancing texture; gold gives a soft warm light, but will give a slight colour cast, which will show on a white animal; white, meanwhile, gives off a fairly soft and neutral light.

Although umbrellas are used mainly on monobloc flash units, there are attachments available that will allow them to be attached to accessory flashguns.

Monobloc flash units will need some kind of light modifier to soften or diffuse the light. In this close-up image the umbrellas can be clearly seen in the catch-lights. The single flash unit was fired into a white umbrella to give a soft, even light.
Persian cat
Canon D30, 90mm macro lens, single flash unit fired into a white umbrella

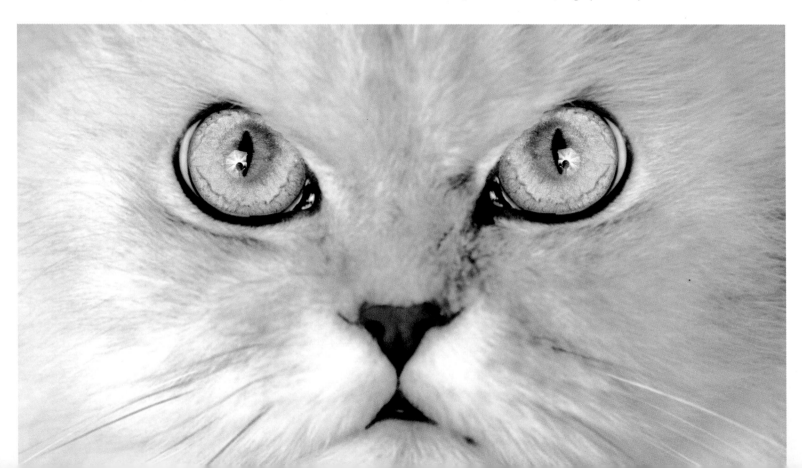

Natural Light

Although this section deals with indoor portraits, natural daylight can still be utilized. However, you will need large windows (patio doors are fine) and a reflector to fill in the shadows. When setting up your studio, try to have the daylight illuminating your pet on one side. On the opposite side, place your reflector so that it throws some light back into the shadow area. This technique will produce an image with good definition and texture of the fur. Move the reflector to change the angle of it in relation to the subject, to see how this affects the photograph. If you do position your subject with the light coming straight onto it, be aware that you may cast an unwanted shadow over the whole image if you are between the window and the animal.

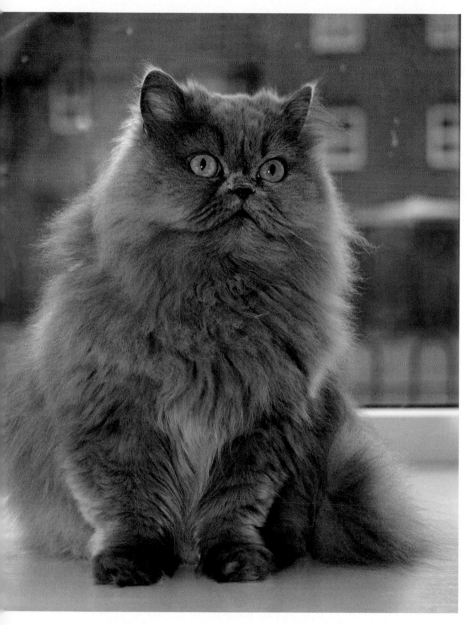

For most indoor portraits you will need some form of artificial lighting but, if you can position your pet near a large window or a set of patio doors, you can use natural daylight. A reflector will need to be put on the opposite side of the light source to soften the shadows.
Persian cat
Canon D30, 50mm lens, natural daylight, reflector

HOW TO TAKE THE PHOTO

The techniques that are used for taking portraits of pets outside can be easily applied to an indoor studio setting, but you have more control over the lighting. Composition is just as important although, if you are using backdrops, it can be more difficult to take full-length images of larger animals, such as the bigger breeds of dogs. This is especially true if you are working in a small room with limited space.

Backdrop

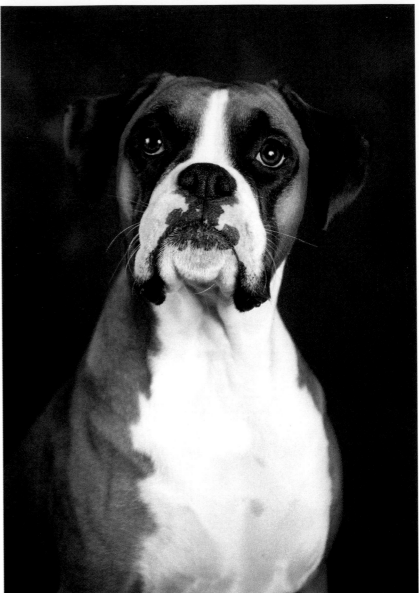

Flashlight or units should be positioned at a 45° angle to your subject. A three-quarter angle is preferable to a head-on position. The dog's head should be the same side as your main light source.
Boxer
Canon D30, 90mm lens, two studio flash units, 1/60sec at f/11

Dogs

When taking studio portraits of large dogs, it is better to concentrate on a head and shoulder portrait. Position the dog so that it is sitting at an angle to the camera, with its head facing the same side as your light source. If you are using a monobloc unit or a flashgun attached to your camera via a sync cable, it should be situated approximately 45° to one side of the camera and set slightly above the animal's eye level. The flash unit should be fired into a white or silver umbrella and angled downwards.

The dog should be positioned fairly close to your chosen backdrop as, if you move the dog too far forward, the backdrop will not receive enough light and will appear very dark in your photograph. If you are using a material background, ensure that you have chosen a colour to complement the colour of your dog's fur. If your dog is small, it may be helpful to put the animal on a block to raise it up slightly. Make sure it is not too high, in case it injures itself trying to run off.

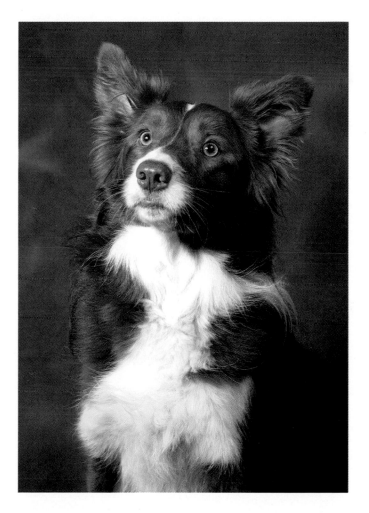

Backdrops should complement your subject's colouring and the dog should be positioned fairly close to the backdrop, to prevent it from being under-exposed.
German shepherd and red Border collie
Canon D30, 90mm lens, two studio flash units

When taking indoor studio portraits, the rules of composition are the same as for taking photographs outside. If you are taking head-and-shoulder portraits, the focal point must be the eyes and, if you have positioned your lights correctly, there should be telltale highlights in the pupils. When using either a monobloc unit or a flashgun, you will need to set an aperture of at least f/5.6 to ensure that the eyes and the nose of the dog stay in sharp focus. Get down to the dog's eye level and fill the camera frame with the head and shoulders of the dog.

Most dogs are not concerned about the bright light from the flash. In fact, you should be ready to take another photograph immediately after the flash has fired, as the dog will quite often cock its head while it tries to work out where the light came from. If you are using a flashgun, the noise from the thyristor recharging will have the same effect.

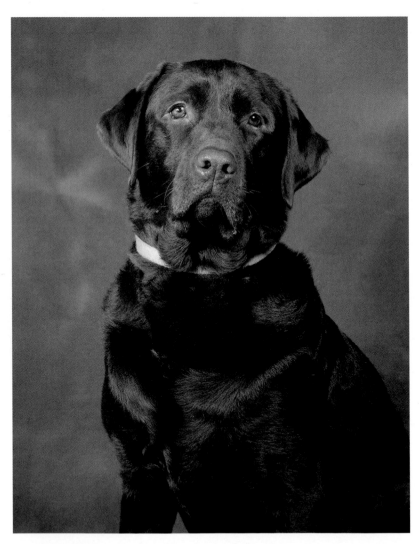

Be prepared to take another picture immediately after you have fired the shutter as, quite often, the noise of the flash gun recharging or the burst of flashlight will prompt the dog to cock its head.
Chocolate Labrador retriever
Canon D30, 90mm lens, two studio flash units

If your dog is happier lying down, that can be a good time to get some close-ups. Remember to lower the level of your lights.
English springer spaniel
Canon D30, 28–135mm lens, studio flashes

Some dogs have a habit of slouching when asked to sit and, no matter how much you cajole or try to manoeuvre it into a better position, it will not co-operate. In this case, it may be better to let the dog lie down.

Taking pictures of dogs in a prone position has a number of advantages and some disadvantages. The biggest plus point is that it makes it harder for the dog to get up and run away and the majority of animals will feel more relaxed. Sometimes a dog will rest its head on its paws and this can make for a great close-up, but be aware that you may need to adjust your lights to accommodate the lower position of your subject. One distinct disadvantage is that, if space is limited, you may not be able to get the whole animal in the frame of the camera unless you are using a wideangle lens. Also, if the backdrop is not wide enough, the dog's legs will overhang onto the carpet.

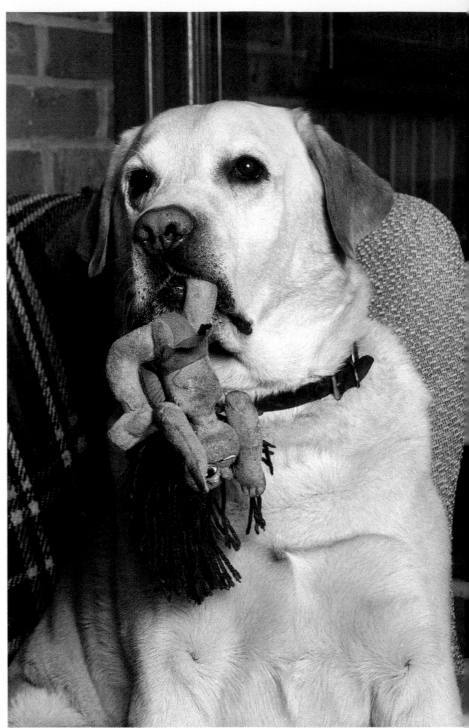

Dogs and cats often have their own chairs and these can be used to show the pet in an informal but relaxed portrait. This Labrador naturally adopted this pose when he sat in his chair. It gives the image a 'human' quality and epitomizes the character of the animal.
Golden Labrador retriever
Canon D30, 28–135mm lens, two studio flash units

If the animal needs some help to relax, offer it a favourite toy.
Golden Labrador retriever
Canon D30, 50mm lens, two studio flash units

If your background is a sofa or favourite chair, the dog will normally have a particular way of positioning itself from the classic 'chaise longue' look to the more traditional 'pipe 'n' slippers' look. Whichever technique you choose, remember the art of pet photography is to capture the personality of the animal. If it wants to pose for you, then take full advantage. However, remember that if you ask your dog to do something that is normally forbidden – such as sit on the family furniture – you will not get relaxed-looking pictures and may find that you have both a wasted roll of film and a very stressed-out animal.

Cats

Just as photographing cats outside requires a different technique from photographing dogs, the same applies to the indoor studio. Cats cannot be posed and will quite often refuse to co-operate. If this is the case, then put the camera away and try another day. However, if you put some forethought into your photographic session, you may have more success.

So, when photographing cats, be prepared to work fast and get your studio ready beforehand. Make sure your background complements your subject, whether it is a material backdrop or a piece of furniture. Cats' fur has a wonderfully soft texture, especially the long-haired variety, so try to use a backdrop that will emphasize this effect rather than hide it.

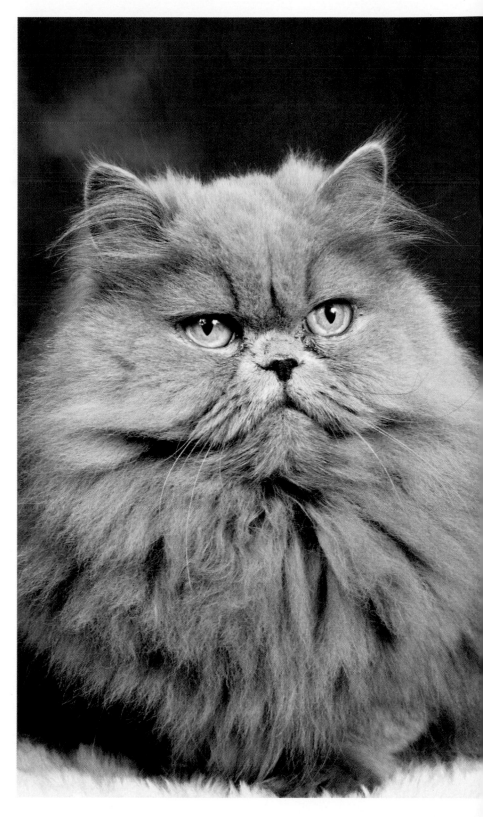

A piece of fur fabric is like a magnet to some cats and once settled they are likely to stay put for quite a while. Although eye contact is important in any portrait, if the animal glances to one side this can produce a very satisfactory image.
Persian cat
Canon D30, 28–135mm lens, two studio flash units

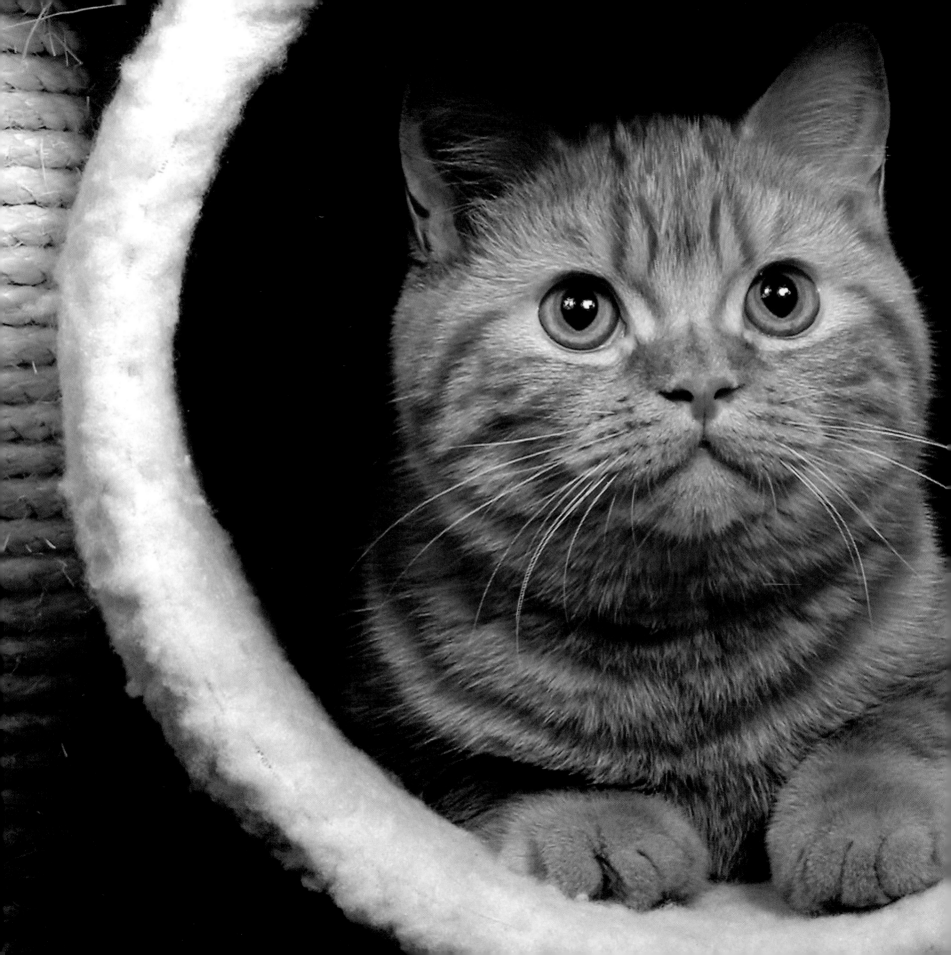

Lighting portraits for cats is very similar to that used for dogs, except that, by using a shoot-through diffuser umbrella, it can add further to the soft texture of the fur.

Cats will need to be raised up off the floor so they are at a comfortable eye level but, once again, make sure they cannot harm themselves if they decide to jump. Most cats love comfort and a piece of artificial fur material will work wonders. Position it on your platform and, in no time at all, the chances are that the cat will have found it and will be making itself at home. However, it can be a problem getting the animal to stay alert long enough to take the pictures.

A useful tip is to move the cat's bed into position and then get a willing handler to put the model into the bed. Quite often, the cat will then stay put and settle down.

Cats have superb eyes and some dramatic close-ups can be taken, but lighting this type of portrait can be difficult, unless you use a telephoto lens that will enable you to maintain some distance and, therefore, allow the flashlight to reach the cat. If you use an accessory flashgun attached to your camera, it will be easier to get in close, as you are less likely to block the light between the flash and the cat. If you get too close, the light will miss your subject.

If you want to get some movement into your cat pictures, you will need a helper and some cat toys. One of the best types to use is a cat wand, which is a long flexible stick with either a feather or small toy attached to a line. Most cats find this irresistible when it is dangled in front of them and will quite often swipe a well-aimed paw at it. This is the moment to fire the shutter button.

This was a classic grab shot. The lighting units were not set up properly, hence the heavy shadows under the barrel, but the cat just sat there waiting to be photographed. The moral of this picture is always be ready and, if an opportunity presents itself, then fire that shutter button.
Domestic short-haired cat
Canon D30, 28–135mm lens, two studio flash units

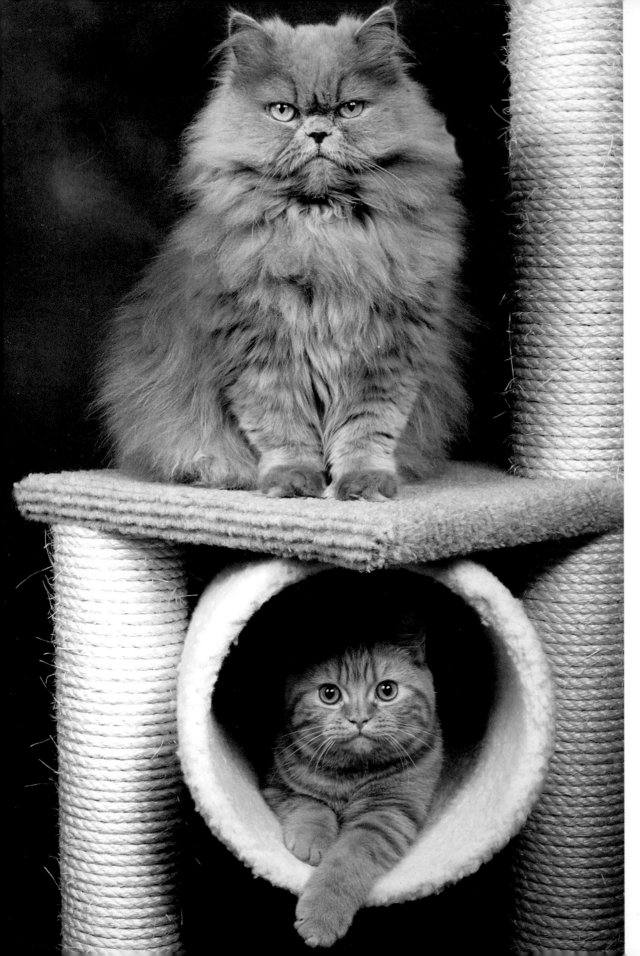

These two cats were quite happy to pose for the camera but, before taking any photographs, time was spent playing with them on the cat tower. This gave them plenty of opportunity to relax and lose any fear of the background and flashlights.
Persian cat and domestic short-haired cat
Canon D30, 28–135mm lens, two studio
flash units

Small Pets

With small creatures such as hamsters, gerbils, and even ferrets, we really can let the imagination run wild when using an indoor studio. In the first instance, it is a very safe environment (providing we keep the cat out of the way). However, all small pets tend to be very fast and agile, so you must ensure that they cannot escape from the area where you are taking your pictures. When setting up a studio for small animals, you basically have two choices: formal or natural.

This is not a particularly natural pose but it is, nevertheless, quite amusing. The handler held a piece of lettuce just above the hamster's head and out of shot and, the first couple of times this was done, it stood up on its back legs to try and reach the food.
Golden hamster
Canon D30, 90mm lens, one studio flash unit

A formal portrait may consist of a backdrop similar to one that you would use for a dog or cat, although obviously smaller. A large sheet of paper with a painted or computer-generated pattern on it will suffice. It needs to be long enough to cover part of the floor or table surface as well as high enough to ensure a clean background. You could include some props in your portrait, such as brightly coloured toys or tubes. Mice, gerbils and hamsters are very inquisitive and love to explore any nook or cranny. As a photographer, you can take advantage of this to secure some interesting and visually pleasing portraits.

Small, furry creatures nearly always belong to young children, so try to include them in a formal portrait along with their pet. This can be a good way of showing how tiny some of these creatures are compared to their owners. You will need to use a telephoto lens to keep a reasonable distance from the animal and bring it up larger in the camera frame.

A simple, formal portrait of a hamster. A piece of lettuce was offered as a bribe to keep the animal still and to add interest to the image.
Hamster
Canon D30, 90mm lens, 550 EX flash unit

A natural set-up involves more work but the results can be
very rewarding. Some research should be undertaken before
attempting to create a natural-looking set. The main aim is to
construct a mini-habitat on top of a table or bench, so that the
animal can be photographed in an environment similar to the
one from which its ancestors originated.

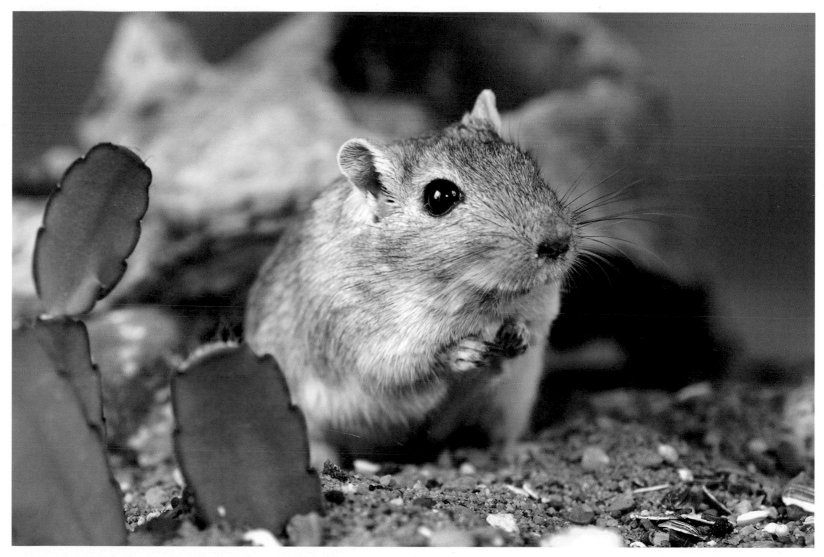

Food can be invaluable for keeping nervous pets in one place long enough to
take pictures. Sunflower seeds and raisins were used to settle this gerbil. An
added bonus is that they always eat standing on their back legs, which gives
another dimension to the image.
Gerbil
Canon D30, 90mm lens, 550 EX flash off-camera

Gerbils and hamsters originate from deserts or very barren landscapes and this habitat is relatively easy to recreate using some sand, stones and dried grass. Spread a layer of sand over a piece of wood or a large flat baking tray, positioning a collection of stones or pebbles and some dried grass in the fore- and background. As this type of creature tends to be nocturnal, use a piece of black velvet as a backdrop to give the impression of night. You can also introduce some seeds or a favourite food into an area that is photogenic.

Here, a few stones, a couple of pieces of wood and some cactus seedlings create a desert environment.
Canon D30, 28–135mm lens, 550 EX flash

The chances are that the animal will find the treats and will start to feed. Work fast and keep taking photographs for as long as the animal is in position, as it won't be long before it has eaten its fill and will venture off to explore.

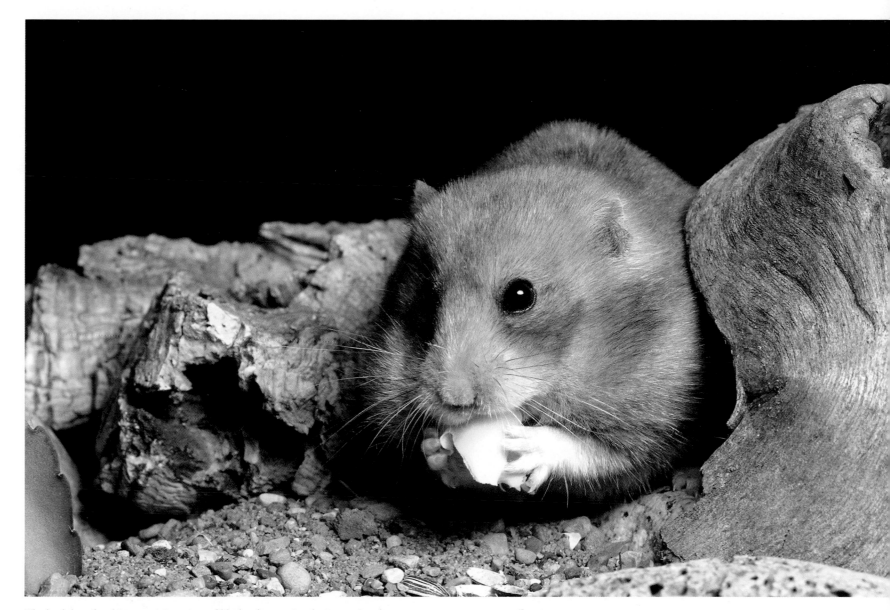

The backdrop for this portrait is a piece of black velvet to give the impression that the picture was taken during the night. Once again a small piece of food was enough to entice the hamster to stay still long enough to get the picture.
Golden hamster
Canon D30, 90mm lens, one studio flash unit

Essentially, the type of lighting set-up for taking pictures of small animals is no different from that used for cats and dogs. In many ways, an accessory flashgun is easier to use, as it is more mobile and ensures that the photo is correctly exposed, especially if the subject will not remain still for very long.

The monobloc flash unit is fired through a diffuser umbrella to soften the light. It is positioned slightly above the set and at an angle of approximately 45°.

An accessory flashgun is attached to the camera via an off-camera flash cable to ensure that the dedication between the two pieces of equipment is maintained. The flashlight is being softened with a plastic diffuser.

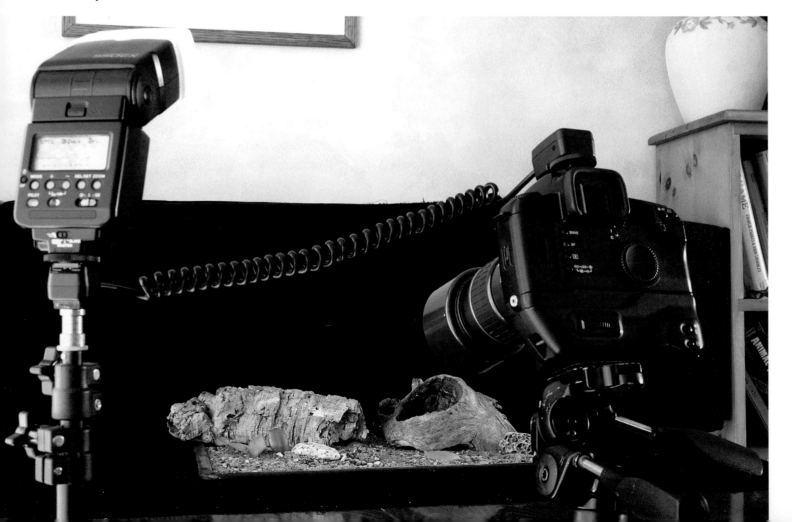

Focusing can be the most difficult technical aspect to get right when the animals tend to be small and may not stay in position for very long. If you are using a camera with a fixed lens, there is little you can do. This type of camera also normally has a fixed aperture setting, so you should find that the photographs are in focus, providing you do not get too close to your subject.

If you are using a zoom or SLR camera, focusing can be more of an issue, but modern-day cameras use autofocus and, as long as the pet stays still, the camera will be able to lock onto the subject.

The handler placed this gerbil at the rear of the piece of driftwood and the animal instinctively stopped at the lip to check all was clear before coming out. By pre-focusing on the lower edge of the log, a number of photographs could be taken before the gerbil made its dash for freedom.
Gerbil
Canon D30, 90mm lens, 550 EX flash off-camera

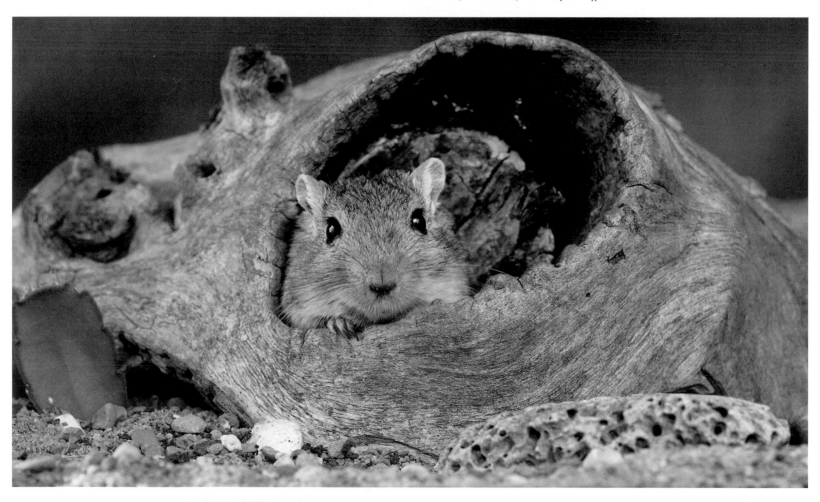

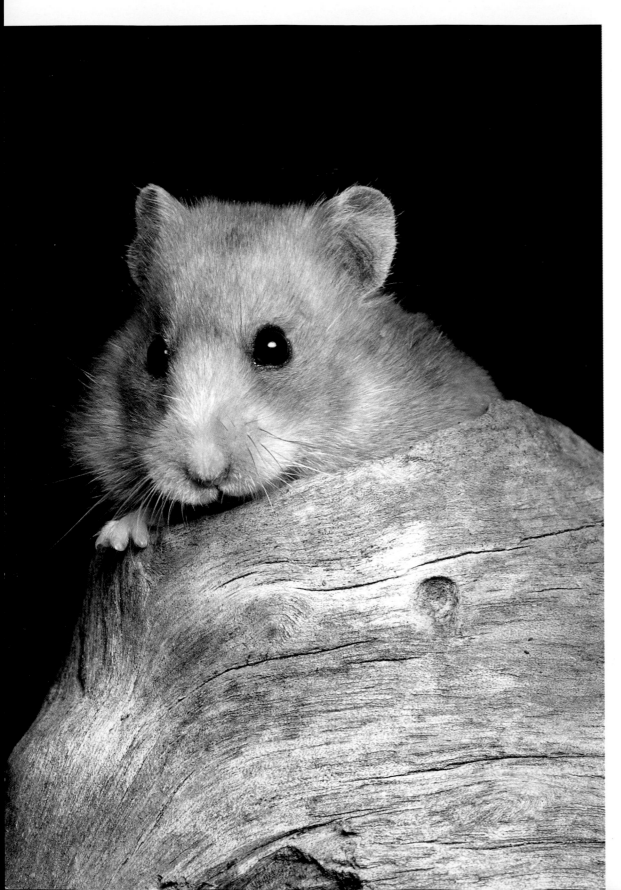

A similar technique was used to photograph this
hamster. It naturally stopped at the mouth of the log
to check all was okay before making its exit.
Golden hamster
Canon D30, 90mm lens, one studio flash unit

If the animal is moving around, you may need to resort to manual focus or, if you are fortunate enough to own a camera that has a setting that allows the lens to follow and focus on a moving subject, this should enable you to achieve a reasonable success rate. Remember, when taking photographs of pet animals, practice makes perfect.

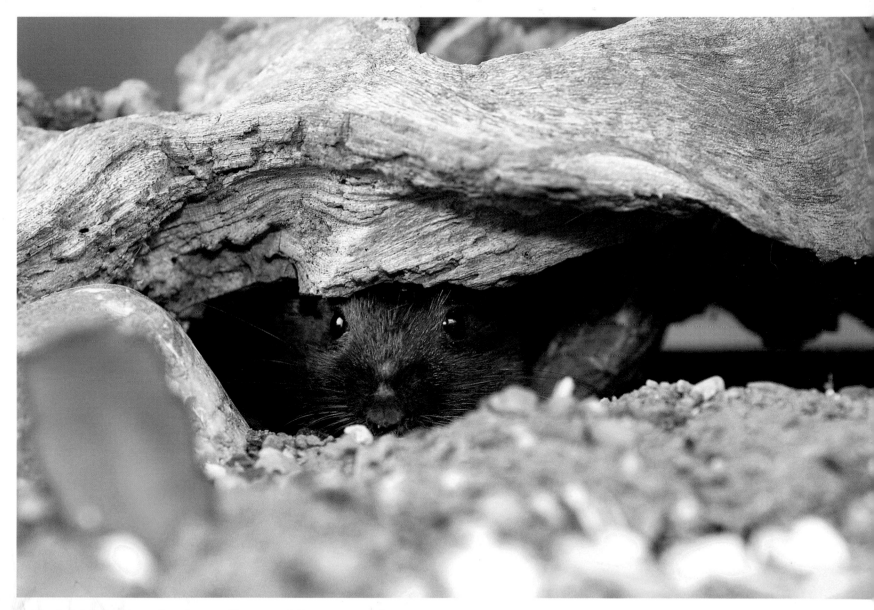

Patience is definitely a virtue when photographing pets and, if you are prepared to take your time, you will be rewarded.
Gerbil
Canon D30, 90mm lens, 550 EX flash off-camera

When making mini-sets for rabbits, guinea pigs and ferrets you can create a woodland scene which, although in the case of guinea pigs is not necessarily a natural setting will, nevertheless, make an interesting backdrop for your portraits. Collecting fallen leaves and using them for 'ground cover' looks natural and the colours can contrast nicely with the animal's fur. Build up the rear of the set using an old log and some dried bracken or grass, but make sure that the height of the set is sufficient to accommodate long ears.

A simple table-top set made from some fallen leaves, a piece of log and some dried grass can form a perfect backdrop for photographing small pets such as ferrets, rabbits and guinea pigs.
Canon D30, 28–135mm lens, 550 EX flash

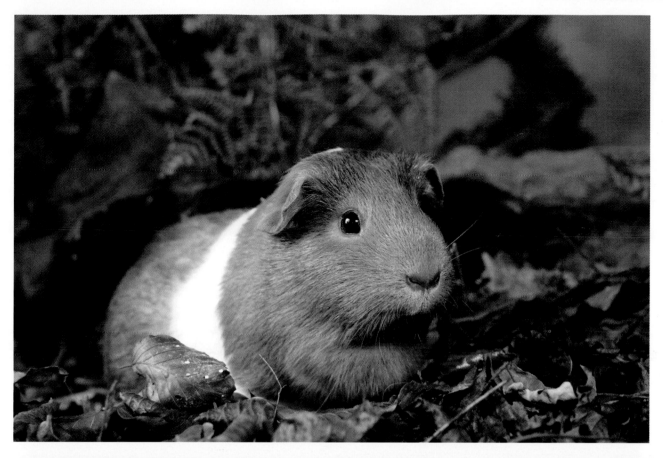

Although guinea pigs do not originate from woodland areas this kind of set suits the colouring and tones of the creature. The set was no bigger than a standard dining-room table but, by changing the angle the pictures were taken from, a variety of images could be produced.

Short-haired guinea pig Canon D30, 28–135mm lens at 35mm, 550 EX flash off-camera

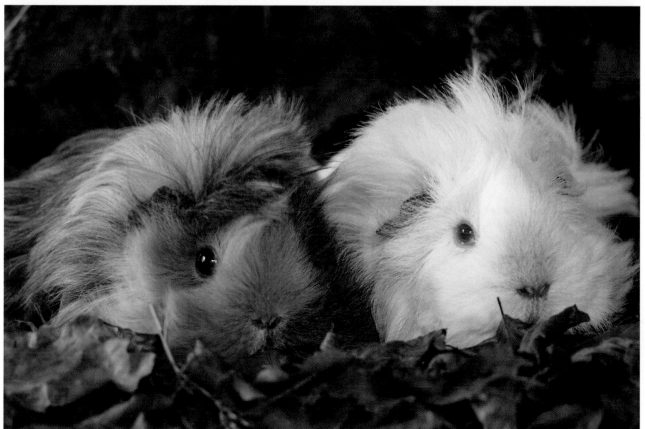

Long-haired guinea pigs Canon D30, 28–135mm lens at 35mm, 550 EX flash off-camera

You will need a handler to calm the animal and ensure that it does not jump off the table although, when threatened or unsure of its surroundings this type of pet will sometimes stay quite still – a characteristic that can be used to our advantage. Once the animal has settled you should be able to capture some images reasonably quickly, but be prepared to call on your repertoire of whistles and clicks to encourage it to lift its head.

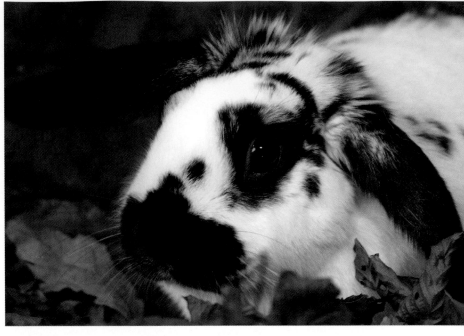

Once your pet is settled it should happily sit quite still, but always keep a handler close at hand, just in case it does decide to make a run for it.
English rabbit
Canon D30, 28–135mm lens, 550 EX flash off-camera

If you use a zoom lens you will be able to get close-ups of your pet. Although the head is positioned towards the middle of the picture, the ears form a frame around the rabbit's head, giving a pleasing composition to the image.
English rabbit
Canon D30, 90mm lens, 550 EX flash off-camera

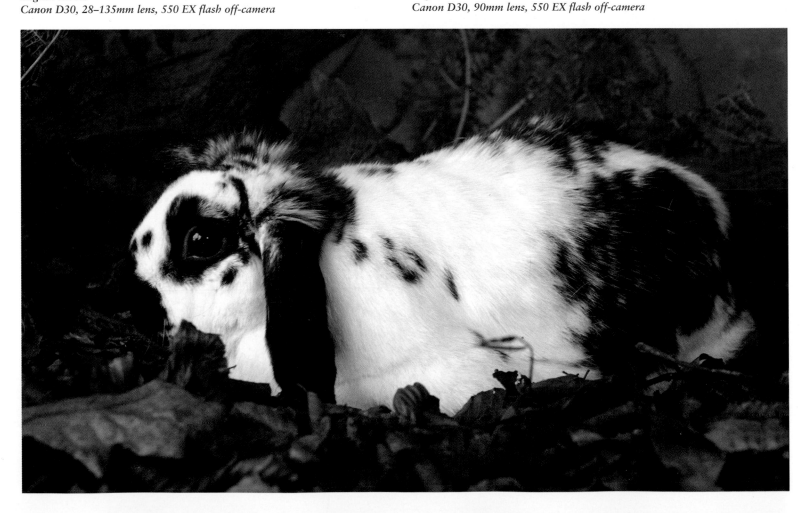

Ferrets demand a different approach and, as with outside portraits, you will need to work fast and be very patient. These creatures are extremely inquisitive and as soon as they are put into a new environment they will rush around exploring every nook and cranny. Whistles and squeaks will generally have little or no effect, so you may have to resort to louder measures, such as the occasional bang on the table or even try shouting its name – the noise might just be enough to stop the exploration and allow you get a few frames fired off.

You must be prepared to use plenty of film when photographing pets. This image was the only successful picture out of nearly 40 taken during an hour-long session with this highly energetic ferret. A loud shout was just enough to stop it momentarily, but it only worked once – after that the animal took no notice of the various whistles, clicks and shouts.
Albino ferret
Canon D30, 28–135mm lens, 550 EX flash off-camera

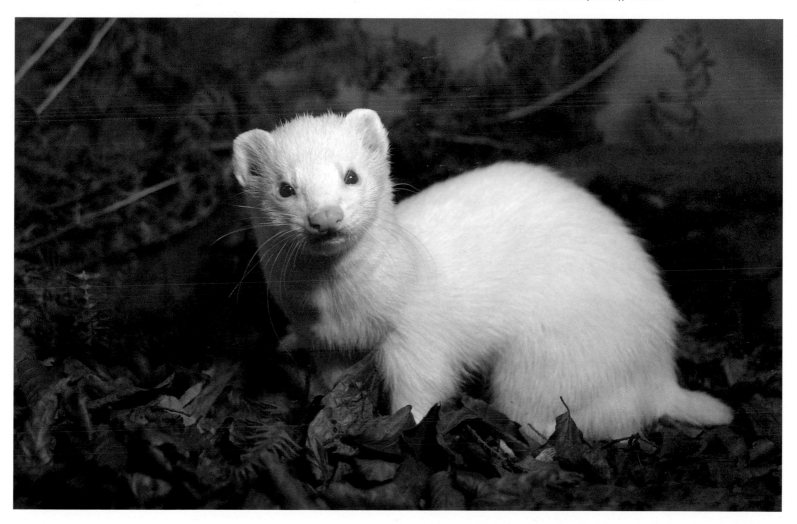

Chapter 5

Action Shots

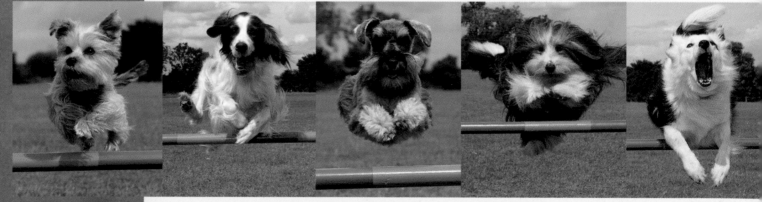

The essence of action photography lies in the ability to capture the speed and incredible agility of the pet. To do this successfully, you must be very familiar with your camera equipment and be able to 'read' the animal's reactions. You will also need to perfect a technique known as 'panning'. In truth, it is unlikely that you will get action shots of cats or any of the small furry creatures. The excitement of action photography belongs to that most common of pets, the dog.

To achieve really dramatic images, you will need an SLR camera equipped with a zoom lens and a motor-wind. Ideally, your camera should allow you to change the shutter speed, as this will enable you to experiment and be more creative. Film speed can also be important: if it is a sunny day, then a film with a speed of ISO 100 will be fine; if the day is cloudy, then you may need to use a film with a speed of ISO 400. The speed of the film will have a direct influence on the shutter speeds that you can select and, in turn, this will have an effect on the final image. Before undertaking any action photography, it is important to understand how the shutter speed affects the way in which a moving object is recorded on film.

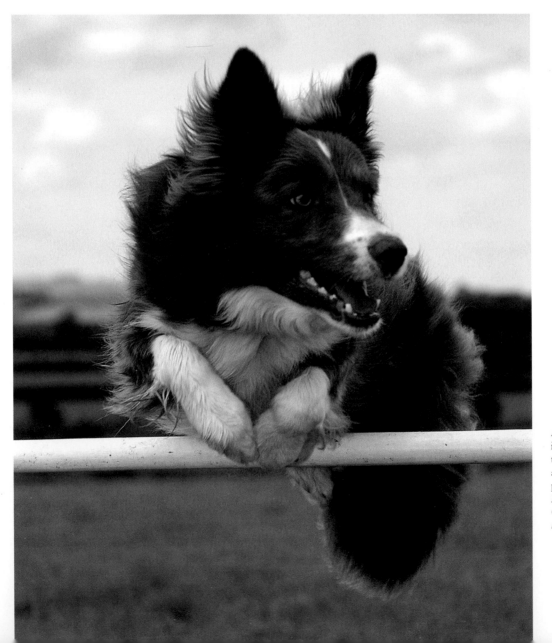

Action pet photography is all about capturing the incredible agility and speed that pets possess.
Red Border collie
Canon D30, 90mm lens, 1/750sec at f/5.6

SHUTTER SPEEDS

When setting out to photograph your dog (or indeed any pet) in action, be aware of the following four factors:

1. The speed it is travelling
2. The direction it is travelling in relation to the camera
3. The size of the animal in the frame
4. The kind of effect that you want to achieve

There is a simple equation that helps to explain the relevance of shutter speed to the achievable effect:

Fast shutter speed = still image (frozen)
Slow shutter speed = blurred image (movement)

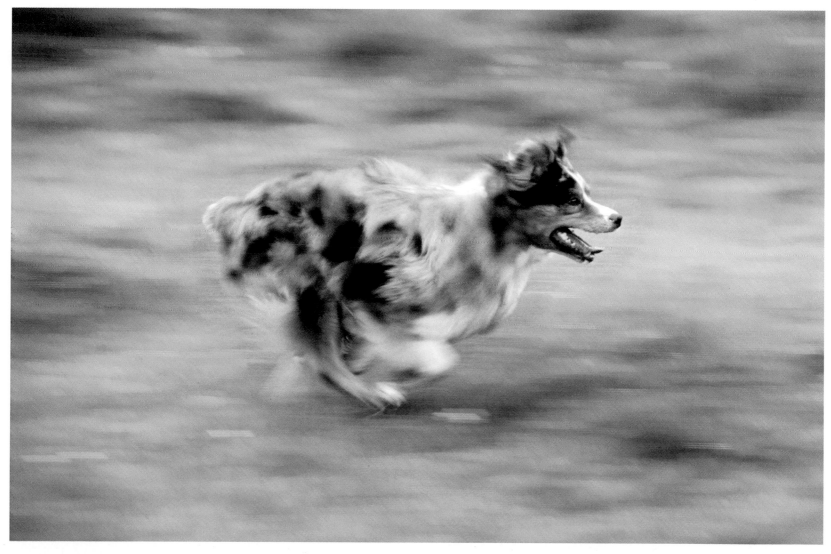

A slow shutter speed will result in an image that shows a degree of motion blur and the slower the shutter, the greater the blur.
Australian shepherd
Canon D30, 28–135mm lens, 1/60sec

A fast shutter speed is one of 1/250 to 1/2000. A slow shutter speed can be anything less but, for practical purposes, 1/15 to 1/60 can produce some exciting results. Once you understand this relationship, it is helpful to have an idea of what the final image should look like. That way, you can set your shutter speed accordingly.

Australian shepherd
Canon D30, 28–135mm lens, 1/15sec

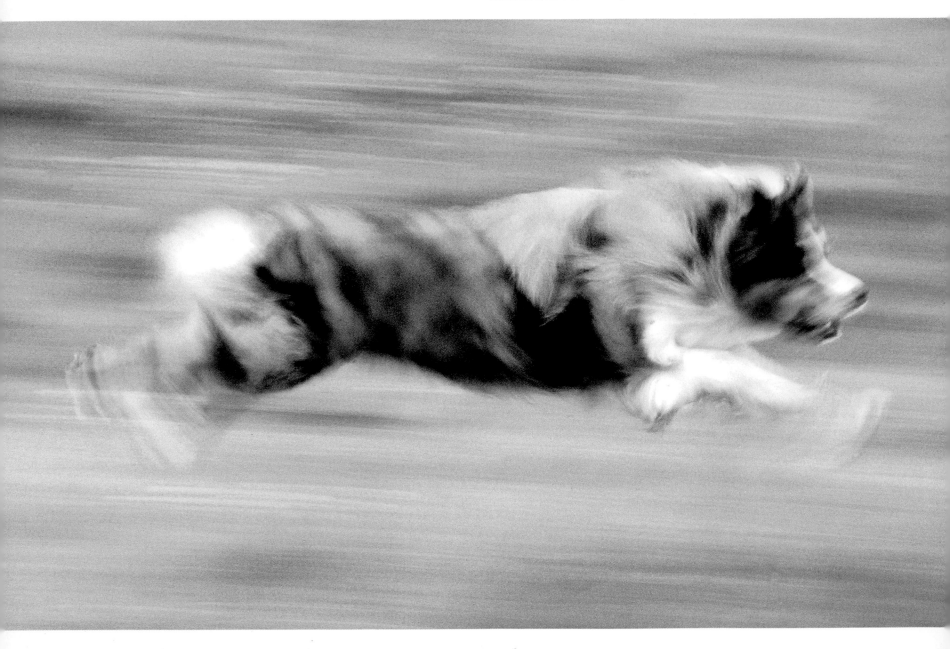

THE TECHNIQUE OF 'PANNING'

In basic terms, panning involves tripping the shutter while tracking the subject in the viewfinder of the camera. You continue to do this even after you hear the shutter close. The aim of this technique is to produce an image that has a sharp (or reasonably sharp) main subject, and a blurred background, thus giving the feeling of speed and movement.

When practising the art of panning, it is a good idea to leave the camera empty of film and to try a number of 'dry runs'. Stand with your legs slightly apart and swivel from the waist, turning to either the right or left so that you face an angle of about 45° (this will be the point where the dog will start). With your legs and feet firmly in place, twist from the hips while

pressing the shutter button. At the same time keep the dog in the same part of the camera frame as you follow its movements.

Once you feel comfortable with this movement, you can load up the camera with film and start to take some pictures, but be aware that you may need to use lots of film to obtain that extra-special photograph.

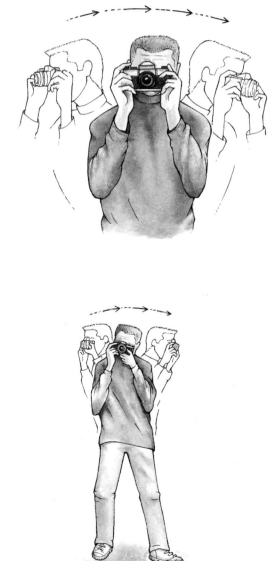

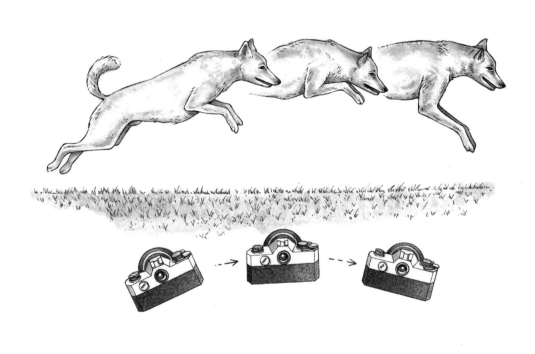

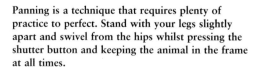

Panning is a technique that requires plenty of practice to perfect. Stand with your legs slightly apart and swivel from the hips whilst pressing the shutter button and keeping the animal in the frame at all times.

Running

All dogs like to run and this gives the pet photographer numerous opportunities to capture the speed and grace of their dog on film. These can be very informal photographs, while the dog is letting off steam in a local park but, in reality, it will be far more productive if you plan your session and get someone to help out with the handling of the dog.

In the first instance, decide what effect you want to achieve. For instance do you want to give the impression of speed (choose a slow shutter speed 1/15–1/30) or do you want to freeze your dog in mid-action (choose a fast shutter speed 1/250–1/2000)? There are no set rules regarding these shutter speeds – it really is just a case of trial and error.

Start with the dog to one side and in front of you (at approximately a 45° angle). You will need to be positioned around halfway between the beginning of the run and the end of the run. This would normally be the distance that the handler can throw a ball or toy. Stand with your feet slightly apart and swivel from the hips so that you are facing the dog and handler. When you are ready, ask the handler to throw the ball parallel to you so that the dog runs across in front of your position. Follow the dog in the camera frame and trip the shutter button, remembering to keep swinging through even after you have heard the shutter close. If your camera has a motorized film advance you should be able to take three or four images.

Once you have perfected your panning technique, you should be able to produce a series of images showing your dog in action.
Golden retriever
Canon D30, 28–135mm lens, 1/1000sec

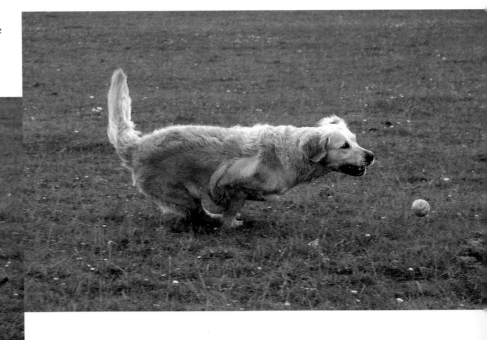

If you use a ball for the dog to chase, keep taking the pictures until the dog has the ball in its mouth. Some very dramatic images can be achieved as the dog opens its mouth to grab the ball, especially if the ball bounces on the ground and the dog misjudges its strike.

Most modern-day autofocus SLR cameras have a facility to track moving objects and, when the subject is moving parallel to the photographer, the autofocus tends to work effectively. If you have a manual-focus camera, you will have to focus continually on the dog as it runs past you. If your handler is a good shot with the ball, you should need only minimal adjustment, as the dog will be on the same focus plane during the whole of its run.

Another simple method is to get the handler to stand next to you and throw the toy or ball out in front. This means the dog will be running in a direct line away from you and then in a direct line back towards you. You will need to be quick with your focusing technique and a good autofocus camera can pay dividends. Quite often, when viewing photographs of dogs running towards the camera, you will get ears and fur flying all over the place and, if you are really lucky, there will be a significant amount of jowl-flapping that is guaranteed to bring a smile to the face.

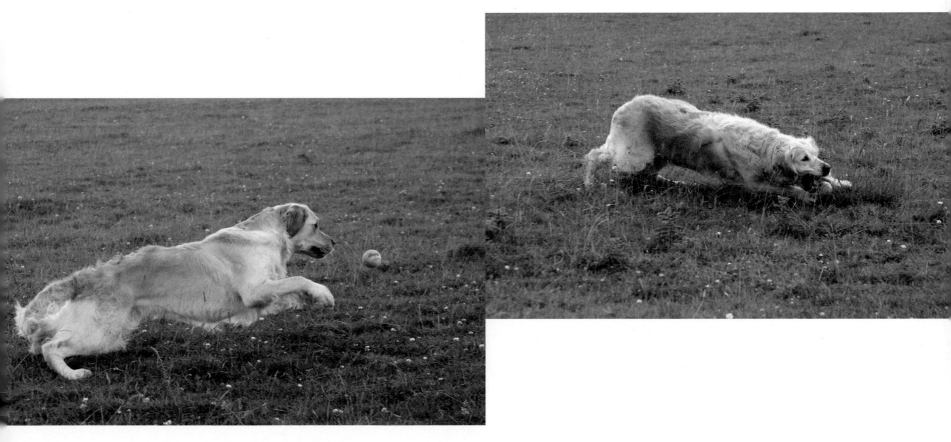

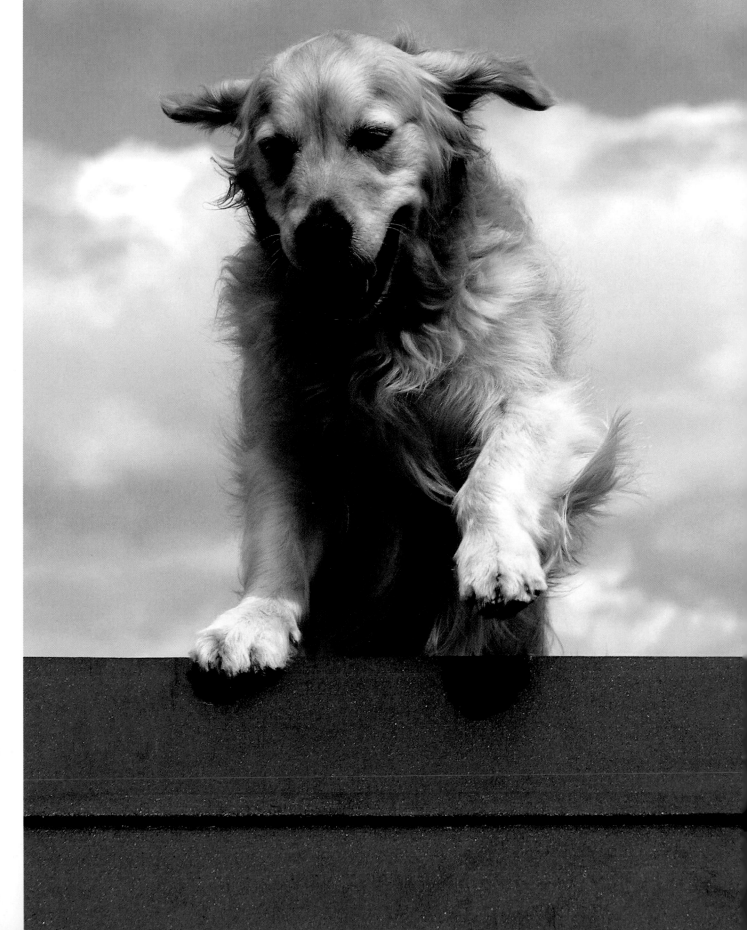

Trained agility dogs
are capable of jumping
over various objects
including large 'A'
frames. As this dog
could not be seen as it
approached the jump
the camera was pre-
focused on the top edge
and the shutter fired as
the dog pulled itself
over the top.
Golden retriever
Canon D30, 90mm
lens, 1/750sec

Jumping

Photographing dogs while they are jumping requires a totally different technique. Once again, you will have to draw on your understanding of shutter speeds so that you can freeze the dog in mid-air. There are two ways to take jumping pictures: the first is with the dog jumping directly at the camera, the second is with the dog parallel to the camera.

Taking head-on images is the easier of the two options. You will need to set a shutter speed of at least 1/500 or faster. This will enable you to stop the dog in mid-action. You will also need to set the aperture to at least f/5.6 so that the depth of field is sufficient to keep the image sharp. A telephoto or zoom lens is vital, as this will enable you to adjust the framing of the photograph and, more importantly, will give you sufficient working space to prevent the dog landing in your lap.

Focusing is critical: it is best to pre-focus on an area of the horizontal bar where the dog is likely to jump and to fire the shutter as the dog clears it. If you are using an autofocus camera, you will need to lock the focus. This is normally done by holding the shutter button halfway down, before recomposing the picture by putting the bar in the lower third of the viewfinder. Use the portrait format (vertical), and make sure you leave enough room at the top of the frame to allow for the height of the dog's head (small dogs have a surprising habit of jumping very high and you can end up with pictures of headless dogs).

With practice, you can take photographs of the dog in a variety of positions. If you take the picture early, you will end up with the dog stretching upwards as it launches itself over the jump. Hold on for a split second and you will get the dog with its legs tucked up under its body on top of the jump and then, immediately afterwards, as it starts to stretch out ready for landing. The first two positions are definitely the most photogenic.

When taking photographs of a dog jumping parallel to the camera, the shutter speed will need to be significantly faster to prevent motion-blur of the dog. You may need to use anything up to 1/2000 depending on the breed of dog and the speed that they run and jump. Focusing is again very important and, as dogs may not always jump over the same point, you should pre-focus on the centre of the bar. It can be a good idea to ask the handler to do a couple of dry runs so that you can get a better idea of where to stand and frame the image. Use the camera in landscape (horizontal) format, as this will give a better composition to the picture, but do not zoom in too close to the jump as you may well find that the dog's head goes out of the frame.

As your timing and technique improve, you can catch the dog as it launches itself over the bar. Pre-focus on the jump and use a fast shutter speed to freeze the action.
Boxer
Canon D30, 90mm lens, 1/750sec

The panning technique used for the running shots can be utilized for jumping images. The main problem here is the shift in the dog's position when it launches itself into the jump. However, panning can be used to good effect if the subject has been trained to 'long-jump'. Many agility or working trial dogs are highly trained and one of the disciplines that they perform in competition is a series of low jumps that cover a spread of around 2m (6ft).

By using the panning technique and a fast shutter speed this collie has been caught at the beginning of the long jump. If you have a motor-wind on your camera keep the shutter pressed ...
Red Border collie
Canon D30, 28–135mm lens, 1/1000sec

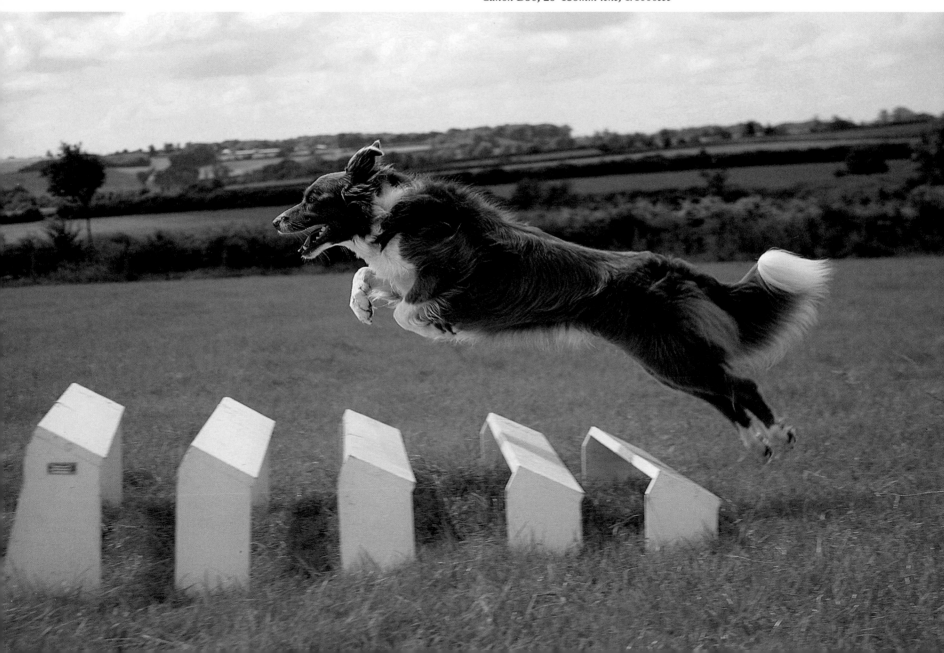

Your own dog might be more used to jumping ditches but the principle is the same: start with the dog sitting to one side of the jump, position yourself halfway along the length of the obstacle and follow the dog as it negotiates the jump, firing the shutter button simultaneously; keep the dog in the camera viewfinder at all times. Do not expect the success rate to be high but, with perseverance, it will be possible to capture that extra-special photograph.

... or wait a split second longer and catch the dog as it reaches the end of its leap.
Red Border collie
Canon D30, 28–135mm lens, 1/1000sec

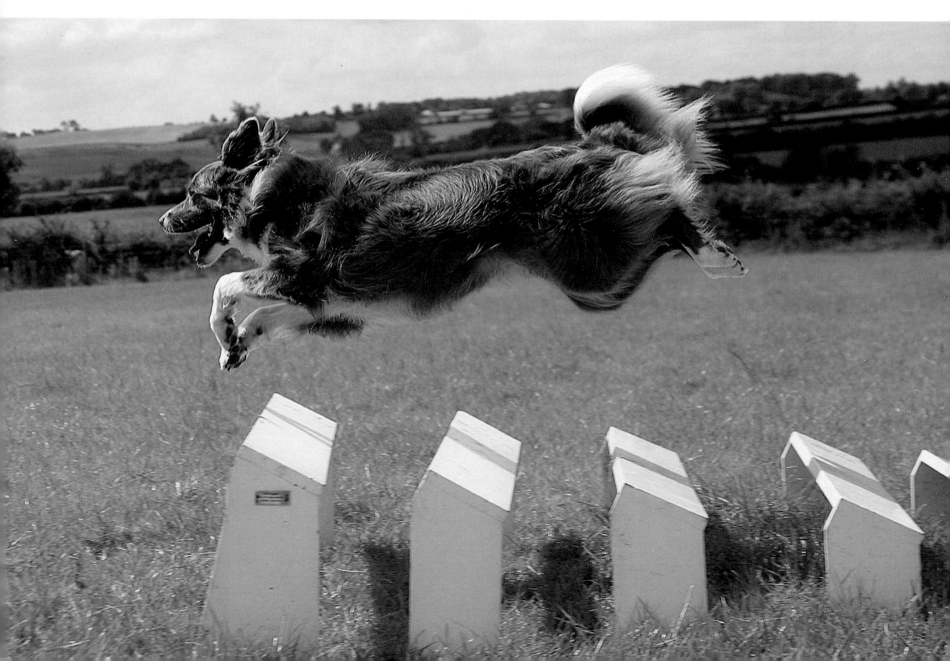

WATER

Let's face it, the majority of dogs like water and photographers can use this love of the wet stuff to great effect. There are no hard-and-fast rules regarding photographing swimming dogs, except that you will normally need to include something else in the picture to increase its visual value. Dogs tend to swim fairly slowly, so focusing is not really an issue and, whether you are using an autofocus or manual-focus camera, you should be able to get sharp images with little difficulty. Ideally, you need to get down as low to the water's edge as possible, but do be careful, as water and modern-day camera electronics do not enjoy each other's company.

Bracco Italiano
Canon D30, 28–135mm lens

German wire-haired pointer
Canon D30, 28–135mm lens

Get as low to the water-line as possible and either try to capture the dog against some rushes, or include a reflection.

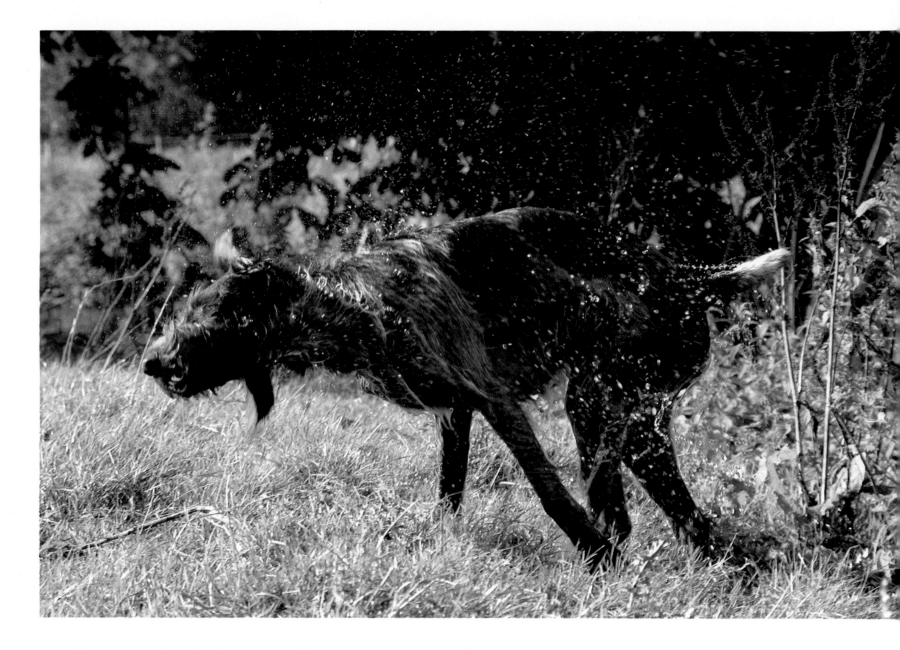

Have the camera ready as the dog gets out of the water, too. If you position yourself so that the sun is facing you when the dog shakes the surplus water from its coat, it will be back-lit and the droplets of water will look as though they are glowing. Use a slightly slower shutter speed of around 1/30 to give the picture a feeling of movement, or use a faster shutter speed of around 1/125 to freeze the droplets of water in mid-air.

Here, a shutter speed of 1/60 was used to capture some of the dog's movement as it shook itself dry.
German wire-haired pointer
Canon D30, 28–135mm, 1/60sec

Some dogs are very bold and enter the water in spectacular fashion. The best photographs are taken just as they enter the water and, if you are lucky enough, you can freeze the image just as the dog touches the surface so it can appear that it is walking on water.

Although not really action pictures, keep a careful look out for reflections in the water as well, especially if your dog is standing still and the surface of the water is flat. You will need to use a wideangle lens so that you can include both the dog and reflection in the picture. Of course, if you are feeling really 'arty' you could just photograph the reflection ... but only if it will make a good picture.

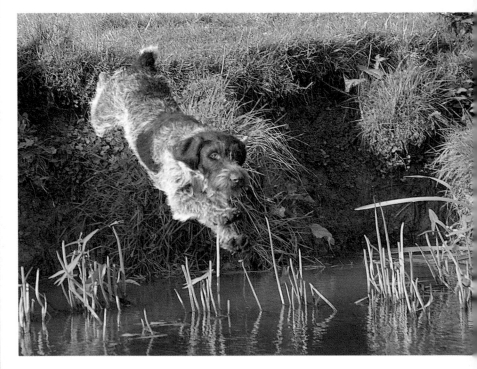

Some dogs are very bold when they leap into the water and occasionally luck will play a part in getting that once-in-a-lifetime image.
German wire-haired pointer
Canon D30, 28–135mm lens at the 135 end, 1/1000sec

The direction of the evening sunlight is ring-lighting the fur of the dog and, because the head is in shadow, a burst of flash has been used to put some catch-lights in the eyes.
Border collie
Canon D30, 28–135mm lens, 550 EX flash

Chapter 6

The
Digital Solution

Digital imaging is the fastest-growing area of photography and, whether you own one of the latest top-of-the-range digital SLR cameras, or a cheaper 35mm compact zoom, you can experience the excitement of manipulating your images on a computer.

There are various methods of capturing a digital image, either through a camera, using a scanner attached to a PC, or by having your films put onto a CD-ROM by your processor. Whichever way you use, once you have your digital file, you can do far more than just look at it.

Nearly all shop-bought PCs are supplied with some type of digital-manipulation software. These can range from the very user-friendly to the more complicated, but the beauty of using this kind of computer program is that, if you do not achieve your desired effect, you can always start again.

Once you have created your masterpiece, you will need to print it out and modern-day ink-jet printers are capable of superb-quality prints on a variety of papers and materials. If you are connected to the Internet, you can e-mail your images to your friends and family, all at the press of a button. If you are really ambitious, you could even design a web page to show off your photographic talents to the rest of the world.

A chronic case of 'green eye' or a clever piece of computer manipulation? This image has been produced using a professional software package. The original photograph was turned into a charcoal drawing and the eyes have been selected and colour-changed. The whole image was then given a texture finish to imitate a canvas effect.
Persian cat
Original image Canon D30, 90mm lens, studio flash units. Adobe Photoshop 6.0 was used to create the final picture

THE COMPUTER

Without a computer, you will not be able to enter the exciting world of digital imaging. As technology improves, the specification of PCs and Apple Macs is changing at a dramatic rate and, in many cases, what you buy today will be out-of-date tomorrow, so do ensure that your system can be easily upgraded.

The heart of any computer is the CPU (the microprocessor). Digital images take a huge amount of processing. The more powerful your CPU chip, the faster the computer will run. Imagine your camera produces an image consisting of three million pixels: if you want to rotate the image just a few degrees, the CPU will have to map each individual pixel and then calculate its new position, and that takes a lot of processing. If you are in the market for a new computer system, buy one with the fastest CPU speed that you can afford, as it will literally save you time in the long run.

Most systems today come with high capacity hard drives (HDD), which are the filing cabinet of your computer. The software and any files that you create are stored in the hard drive and, as image files consist of large amounts of data, your hard drive will need to be large enough to cope with this demand. HDDs come in varying sizes but, ideally, you will need one with a capacity of at least 10 gigabytes (GB), which should be suitable for most purposes.

The heart of the 'digital darkroom', complete with graphics pen, scanners and printers. No need for smelly chemicals and a blacked out room to produce your masterpiece.

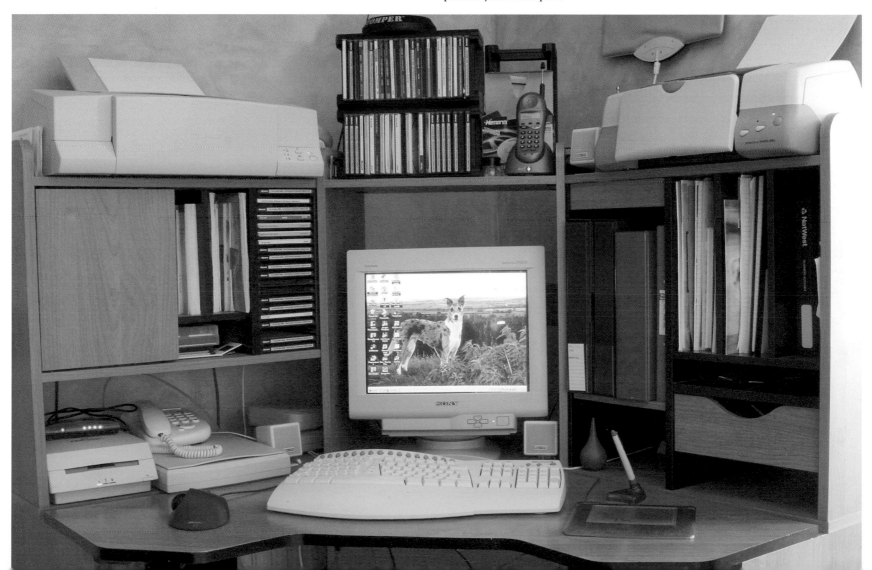

Image-manipulation programmes allow the photographer to produce unique and unusual pictures that could never be created using traditional methods. This picture is made up of two layers: the top one is black and white and the one underneath is colour. Using the eraser tool the black and white area over the dog was removed to allow the colour to show through.
Bracco Italiano
Canon D30, 90mm lens. Image manipulation in Adobe Photoshop 6.0

INTO THE DIGITAL DARKROOM

Because of the diversity of software programs on the market, it would be impossible to ensure that the techniques shown on the following pages can be achieved by all of them, but all should be able to deal with some of the basic tasks.

Cropping

When photographing pets, especially when taking action shots, it can be difficult to get sufficiently close to the animal to ensure that it is large enough in the photograph. You may want to exclude some unwanted feature that you did not notice when you tripped the shutter button. Composition can also be improved by judicial use of the cropping tool, but it is not an excuse for sloppy technique, as it is always better to get it right 'in camera' rather than constantly recompose in the computer.

There are problems associated with cropping images, especially if your pet is quite small in the frame. The camera can only record so much on the film or digital chip and, the smaller the main subject, the less detail will be captured. If you crop in too much, you could find that the image will be degraded to the point where it is unusable and nothing more than a mass of indistinguishable colour. This is another good reason to ensure that your composition is right before taking the photograph.

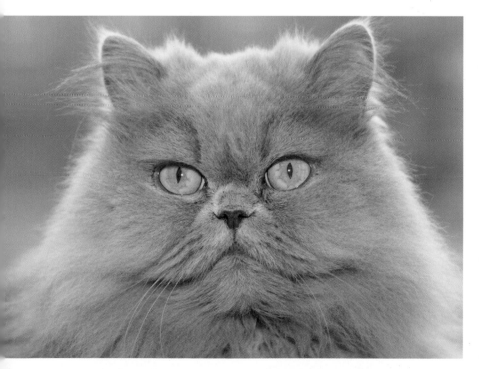

Cropping in the computer can have a dramatic effect on the final image. The eyes on this Persian cat are such a strong element of this picture that I decided to emphasize them by simply using the crop tool to remove most of the head and background details.
Persian cat
Canon D30, 90mm lens, 550 EX flash, diffuser

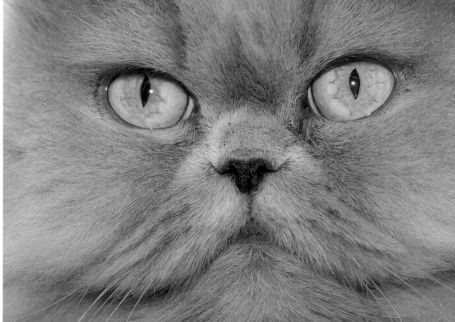

In a matter of seconds a totally new picture has been created. The crop has not been too severe and I decided to keep the mouth of the cat in the frame as this improves the composition.
Persian cat
Canon D30, 90mm lens, 550 EX flash, diffuser. Image manipulation in Adobe Photoshop 6.0

The Clone Tool

The clone, or rubber stamp, tool has to be the most useful implement that image digital-manipulation software has created. Whether you have a telegraph pole growing out of your dog's head or an annoying piece of vegetation spoiling an otherwise perfect photograph of your cat, judicial use of the duplication tool can dramatically transform an image.

In principle, the clone tool simply works by taking samples of colour (pixels) from one part of the image and copying them over the offending object. The most common mistake that people make when using this gizmo is that they tend to keep the source point static and this leads to a repeated and very obvious pattern in the target area. The secret is to keep moving the selection point so that a natural and irregular pattern is built up over the section of the image that you want to hide.

To get consistently good results requires practice and patience but, when mastered, this trick can rescue a disappointing picture and turn it into a masterpiece.

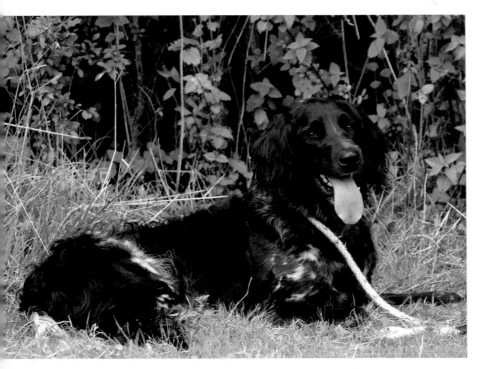
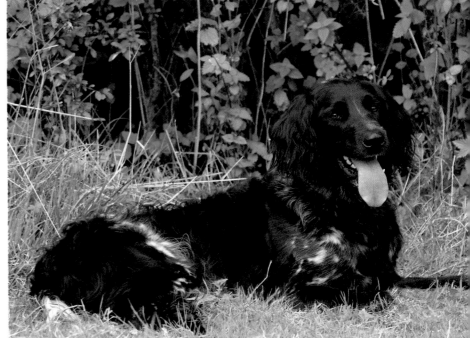

With careful use of the clone tool, you can remove unwanted elements from your pictures. In the picture on the right, the dog's lead has been cloned out.
Munsterlander
Canon D30, 28–135mm lens. Image manipulation in Adobe Photoshop 6.0

Montages

The word 'montage' simply means a composite picture or, in layman's terms, a picture made up of lots of pictures. When setting out to create a montage, it is a good idea to have a rough idea of the design before you start. With basic software programs you will be able to 'cut' and 'paste' your digital pictures into one montage. Professional programs permit you to use separate layers for each image and allow for greater control and creativity, but be prepared, for the learning curve is very steep. Apart from images, text and coloured borders can be used to good effect and, remember, if you do not like the results you can start all over again.

As your proficiency grows, try making some montages of your favourite pictures. *Canon D30, 28–135mm lens. Image manipulation in Adobe Photoshop 6.0*

Borders

One of the simplest techniques to enhance any picture is the inclusion of a border. These can range from simple coloured lines to a faded frame, called a vignette. There are specialist programs on the market that have pre-designed borders supplied on CD-ROM and, although these can be quite expensive to buy, they can add that extra something to your photograph. Some consumer software will come with a variety of built-in borders and it is worth experimenting with these, but avoid the garish and the gimmicky ones.

Vignette borders are a simple but effective way of enhancing your pictures.
Burmese kitten
Canon D30, 50mm lens. Image manipulation in Adobe Photoshop 6.0

Colour Changes and Toning

One basic function of most of the manipulation-software programs is that they allow you to make changes to the colour or tone of your image. Brightness and contrast can also be adjusted and are normally controlled by either entering values in a toolbox or by using sliders to make the alteration. Most digital-image files will need some tweaking of these basic levels.

If you want to completely change the atmosphere of the picture, some of the consumer-level programs may have pre-set toolbar buttons that will automatically change the image from colour to black and white, or even sepia. If not, you will need to use the Hue and Saturation toolbar. There are many techniques to turn an image from colour into black and white; the most straightforward is to drain the colour from the image, by adjusting the saturation slider so the value is at zero. You might find that you will need to make some adjustment to the contrast to bring back some depth to the image.

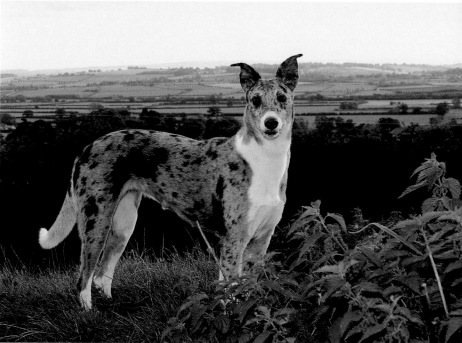

There are various tones that can be applied to your pictures, ranging from black and white to sepia, or anything in between.
Collie x greyhound lurcher
Canon D30, 28–135mm lens, 550 EX flash. Tone changes in Adobe Photoshop 6.0

Sepia toning is very popular, as it gives the image an 'aged' look that can be particularly effective if your pet has been photographed in an environment such as an old chair or even a barn. Once again there are various methods of producing sepia pictures and, if you are using a program that has a pre-set button, then simply click on that and let the computer do all the work for you. If you are using advanced-level software, you may have to make the adjustments yourself, by once again using the Hue and Saturation tool.

If you can enter values for the Hue and Saturation, then a good starting point is 25 and 30 respectively. If you do not like the tone, then adjust the values to taste. Depending on which program you are using, you might find that you will have to click a check box (colorize) to ensure that the adjustments work properly.

Sepia-toned pictures can be produced easily with even the most basic of software packages. Experiment with the Hue and Saturation settings until you get an acceptable tone. *Black Labrador retrievers, Canon D30, 28–135mm lens. Image manipulation in Adobe Photoshop 6.0*

Filters

Many filters that are supplied with software-manipulation programs have no use in pet photography, but there are a few that can be used to good effect.

'Brush' (or 'artistic') filters are able to give the impression that the image has been painted in watercolours or oil paints.

These filters do call for some experimentation to achieve the right effect and usually only work well when there is a good variation of tones in the original picture. When you have created your new masterpiece, you could enhance the effect further by printing it out on one of the many 'art grade' papers that are available for ink-jet printers.

The brush (or artistic) filters give the impression that this image has been painted with a brush.
Yorkshire terrier
Canon D30, 50mm lens. Image manipulation in Adobe Photoshop 6.0

Blur

If you are using an advanced package, you may well be offered the choice of anything up to six different types of 'Blur' filter. However, even the most basic normally gives you the option of using a filter known as 'Gaussion Blur'. This filter lends the image a dream-like quality that can give fur or hair a wonderful soft texture. However, don't overdo the effect, or you will end up with an image that simply looks out of focus.

The Blur filter used for these pictures gives them an attractive, soft, dreamy quality.

English springer spaniel
Canon D30, 50mm lens, two studio flash units. Image manipulation in Adobe Photoshop 6.0

Domestic short-haired tabby cat Canon D30, 50mm lens, two studio flash units. Image manipulation in Adobe Photoshop 6.0

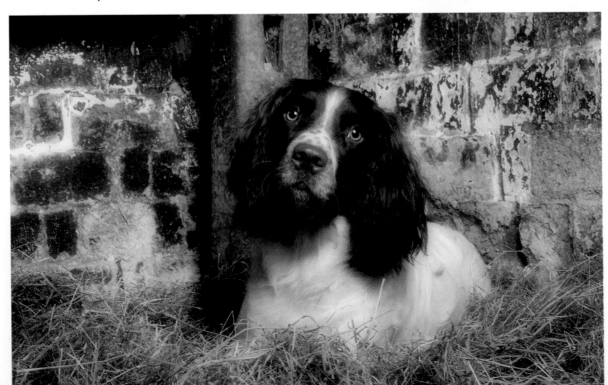

Unsharp Mask

The last filter in the computerized magic box is the bizarrely named Unsharp Mask, which (believe it or not) is designed to sharpen your digital image. Whether you have scanned a photograph, or have taken one using the most expensive up-to-date digital camera available, it will need some degree of sharpening before printing. The Unsharp Mask filter normally has two or three settings available: percentage, radius and threshold. The first two are the most important. Once again, you will need to experiment with this filter but, in general, most images benefit from a percentage setting of 100–200% and a radius setting of .05 to 1.0. A point to bear in mind is that an image will always look sharper on your computer screen than when it is printed.

Producing Prints

Once you have created your masterpiece in the digital darkroom, the next step is producing a photograph that can be shown proudly to your family and friends.

Modern ink-jet printers are capable of producing very high-quality prints (providing the file contains sufficient data). There are issues regarding the archival quality of ink-jet prints but the manufacturers are addressing this. It is always worth remembering that, to get the best prints, you should use the ink and paper that is recommended for your particular printer and, if you want photographic quality, you will need to use a specially coated paper that can cope with the distribution of the ink.

Digital photography is growing at a fantastic pace and, with the increase in the use of the Internet, there are a number of companies offering photographic services via the Web. You can now e-mail your digital file to them and, a few days later, a photograph will drop through your letter box – it couldn't be easier and there are no worries about short-term fading.

Alternatively, you could write your files to a CD-ROM and take it to one of the high street processors who will produce your print using one of the latest digital printers.

Modern ink-jet printers are capable of producing very high-quality prints and, with the increased availability of archival inks and paper, the worry of prints fading is becoming a thing of the past.

Chapter 7

The Final Frame

Many good photographs are spoilt by being hung on the wall in totally inappropriate mounts and frames. This is a great shame, when a lot of time and effort has been spent in taking the image – and perhaps even in manipulating it on the computer – and the following points will help to ensure that your photograph is shown off to best advantage.

Whether your photograph is produced by a processing laboratory, or you print it yourself using a desk-top printer, it will need some preparation before you mount and frame it.

Self-adhesive board can be purchased at any art shop, is simple to use, and will prevent the print curling. First, remove the protective covering from the board then, holding the upper edge of your print away from the adhesive, use a roller to carefully flatten the image, working from the bottom upwards to remove any air bubbles. Once the image is fixed in position, trim the board to size.

Fixing a photograph to self-adhesive board.

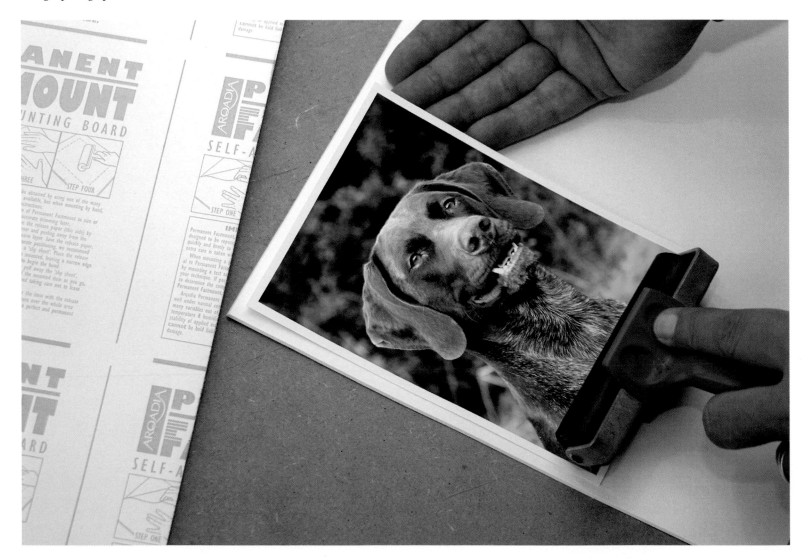

You then have a number of choices: you can take the photograph to a professional framer; buy pre-cut mounts and ready-made frames and put everything together yourself; or you can design and cut your own mounts and then make your own frames.

Whichever route you choose, a neutral-coloured mountboard (such as buff or cream), or one that picks out a tone within the picture, will show your image off to best effect. Mountboard comes in a multitude of colours and varying the mount colour can dramatically affect the finished article.

Ready-made mounts can be bought from most framing or art shops, but DIY mount cutters are available if you are feeling a bit more ambitious. These are very simple to use and produce a bevelled edge on the mountboard which enhances the 'window' effect.

Most cutters come with detailed instructions on measuring and cutting the mounts.

There are various ways of measuring mounts but, as a general guideline, aim for a 5cm (2in) border around the window. Most ready-made frames are manufactured to accommodate this size.

If you are likely to need a lot of mounts, cutting your own with a mount cutter could be cheaper than buying ready-cut mounts.

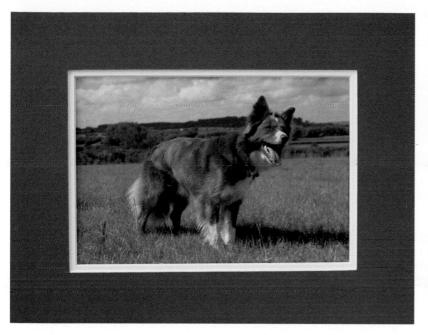

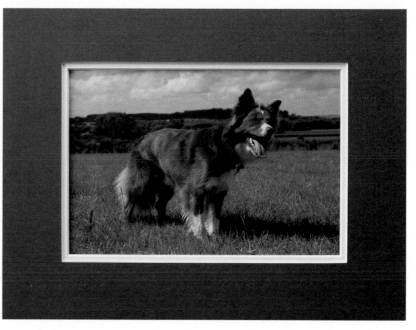

In this particular image, there are a number of colours and tones that could be used to complement the mount: in this first example, a tan mount has been used to highlight the colour of the dog ...

... but there are a significant number of green tones, as well. Here, a mount that reflects the trees and hills in the background has been used, rather than a lighter green that would have competed with the grass

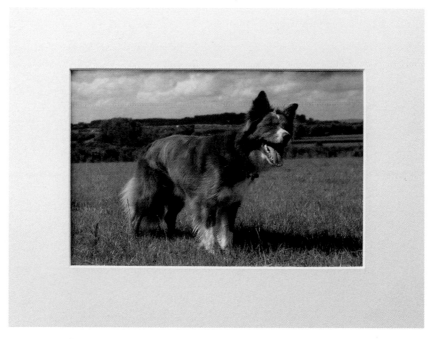

A neutral-coloured mount – such as buff or cream – is a safe option, as it will suit most images regardless of the colour content.

For a black-and-white image I recommend a white mount or a black mount. In this case, a white mount has been enhanced by the addition of a thin black line. This simple but effective technique further adds to the impression that the viewer is looking at the picture through a window.

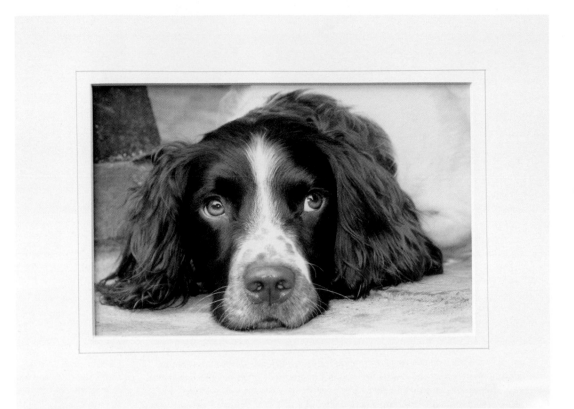

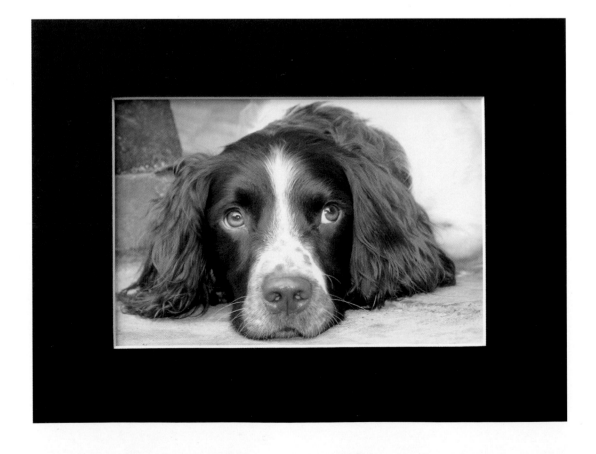

If you are artistic, you can take your picture-mounting to another level. Here, watercolour paper has been laid over self-adhesive board and then images have been painted around the mount to complement the main image. This technique has unlimited potential for any pet, but here it has been used on a portrait of a working gun dog.

The final frame ... you have mastered the art of pet photography and your mounted and framed portrait can be hung proudly on the wall for all to admire.

PHOTOGRAPHIC TERMS

APERTURE

The opening of the lens that lets the light into the camera and exposes the film. Most modern cameras do this automatically

APS

Advanced Photo System: a relatively new film and camera format. Combines ease of use with simple film loading

AUTO EXPOSURE

By measuring available light this feature automatically sets the best shutter speed and exposure for a shot

AUTOFOCUS

An electronic system which focuses the lens automatically

DEPTH OF FIELD

The area in front and behind the subject that is in focus

FOCUSING

The ability to adjust a lens either automatically or manually to get the sharpest image on film

HOT SHOE

An electrical contact fitted to cameras to allow accessory flashguns to be attached

ISO

International Standards Organization. A numerical rating of a film's sensitivity to light, e.g. ISO 100

NEGATIVE

Image or film where all normal tones and colours are reversed. Negative film will produce photographic prints

POSITIVE, SLIDE OR TRANSPARENCY

Positive film that produces pictures that are projected normally

SHUTTER SPEED

Length of time it takes for the camera shutter to open and close. Action pictures will require a fast shutter speed, i.e. at least 1/500sec

SLR

Single lens reflex camera

TELEPHOTO

A lens that effectively increases the size of the image on the film without moving closer to the subject

WIDEANGLE

A lens that gives a field of view greater than 55mm on a 35mm camera. Normal wideangle lenses have a focal length of 18–35mm

ZOOM LENS

A lens that is manufactured so that its focal length can be altered, e.g. a typical zoom lens has a variable focal length of 28–80mm

About the Author

Nick Ridley's busy working life combines his passion for animals and photography, as he works full-time as an Inspector for a well-respected national animal-welfare charity and, in his spare time, as a professional photographer.

Although born in north London his love for the countryside soon developed and so did a keen interest in working dogs, be they agility, sheep- or gun dogs. To be able to photograph a working dog in a working environment is his idea of heaven. In 2000 he set up an event-photography business and on most weekends he can be found 'practising what he preaches'.

Such a busy working life requires boundless energy and enthusiasm, and these Nick has in large measure: he has featured in numerous national TV programmes, made many appearances on local TV news programmes, and his articles and photographs have been published in various animal and photography magazines.

Nick now lives in Buckinghamshire, England, with his wife, two teenage daughters and various small furry creatures.

Image Index

All of the images used in this book were taken using Canon cameras, either a D30 digital camera or an EOS 5 traditional film camera. A variety of lenses were used and these have been listed in the captions, along with the relevant focal lengths. I rarely use a tripod and the most useful pieces of equipment I own, other than my cameras, are a squeaker and an empty crisp packet, so I really do practise what I preach.

In many cases the exposure details were not noted. Pet photography is all about capturing that special moment and it would be fair to say that 'the moment' can be so short-lived that, in the effort to secure the picture, such statistics are sometimes overlooked.

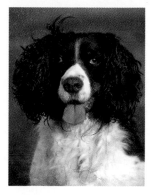

Page viii
English springer spaniel
Canon D30, 28–135mm lens

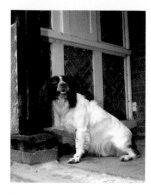

Page 20
English springer spaniel
Canon D30, 28–135mm lens,
550 EX flashgun

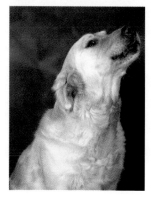

Page 21
Golden retriever
Canon D30, 28–135mm lens,
studio flash units

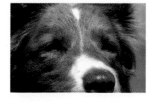

Page 21
Red Border collie
Canon D30, 28–135mm lens

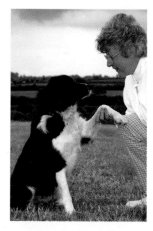

Page 22
Cross-bred spaniel and owner
Canon D30, 50mm lens,
550 EX flash

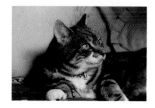

Page 23
Tabby cat
Canon D30, 28–135mm lens

Page 24
Cocker spaniel
Canon EOS 5, 28–135mm lens

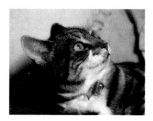

Page 26
Domestic short-haired tabby cat
Canon EOS 5, 28–135mm lens

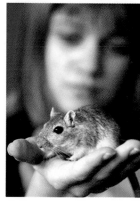

Page 26
Gerbil
Canon D30, 90mm macro lens, f/4.0

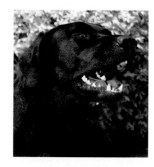

Page 27
Black Labrador retriever
Canon D30, 28-135mm lens

Page 28
English springer spaniels
Canon D30, 50mm lens, one studio
flash unit

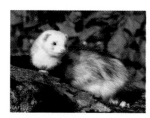

Page 29
Ferret
Canon D30, 90mm lens

Page 29
Bracco Italiano
Canon D30, 28-135mm lens

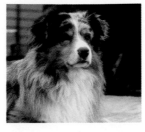

Page 29
Australian shepherd
Canon D30, 28–135mm lens

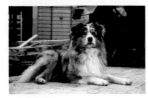

Page 30
Australian shepherd
Canon D30, 28–135mm lens

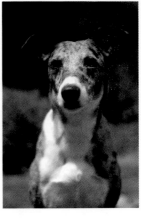

Page 31
Collie x greyhound lurcher
Canon D30, 50mm lens,
1/4000sec at f/1.8

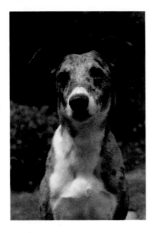

Page 31
Collie x greyhound lurcher
Canon D30, 50mm lens, 1/350sec
at f/5.6

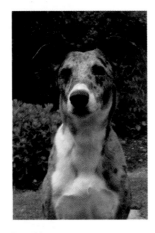

Page 31
Collie x greyhound lurcher
Canon D30, 50mm lens, 1/45sec
at f/16

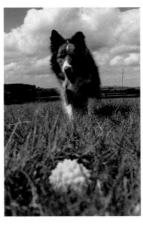

Page 32
Red Border collie
Canon D30, 28–135mm lens at the
28mm end, f/2.8

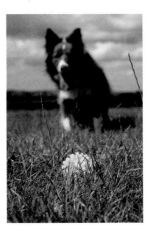

Page 32
Red Border collie
Canon D30, 28–135mm lens at the
28mm end, f/2.8

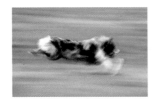

Page 33
Australian shepherd
28–135mm lens, 1/15sec

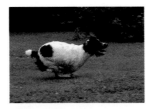

Page 33
English springer spaniel
Canon D30, 28–135mm lens,
1/500sec

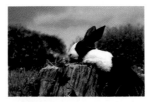

Page 34
Dutch rabbit
Canon D30, 28–135mm lens at the
28mm end, f/5.6

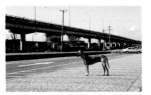

Page 34
Mongrel
Canon D30, 28–135mm lens at the
28mm end

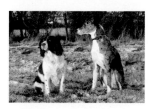

Page 35
English springer spaniel and
collie x greyhound lurcher
Canon D30, 50mm lens

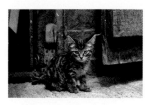

Page 36
Domestic short-haired tabby kitten
Canon D30, 28–135mm lens

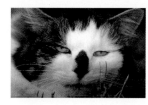

Page 37
Domestic long-haired tabby cat
Canon D30, 28–135mm lens at the
100mm end

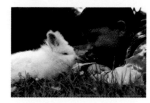

Page 38
Angora rabbit and owner
Canon D30, 28–135mm at the
28mm end

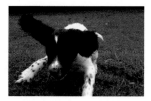

Page 39
English springer spaniel
Canon D30, 28–135mm

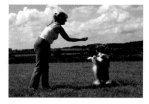

Page 40
Red Border collie and owner
Canon D30, 28–135mm lens

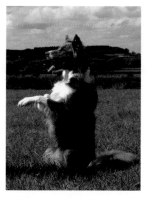

Page 41
Red Border collie
Canon D30, 28–135mm lens

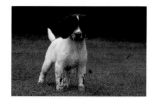

Page 42
English springer spaniel
Canon D30, 28–135mm lens

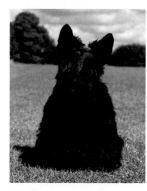

Page 42
Scottish terrier
Canon D30, 28–135mm lens

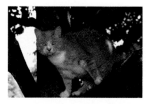

Page 43
Domestic short-haired cat
Canon D30, 28–135mm lens at the
135 end, 550 EX flash

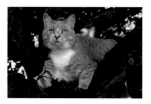

Page 43
Domestic short-haired cat
Canon D30, 28–135mm lens at the
135 end, 550 EX flash

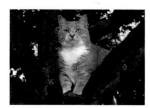

Page 43
Domestic short-haired cat
Canon D30, 28–135mm lens at the
135 end, 550 EX flash

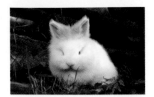

Page 44
Angora rabbit
Canon D30, 28–135mm lens at the
135 end, 550 EX flash

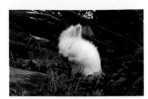

Page 44
Angora rabbit
Canon D30, 28–135mm lens at the
135 end, 550 EX flash

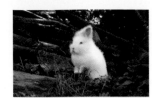

Page 44
Angora rabbit
Canon D30, 28–135mm lens at the
135 end, 550 EX flash

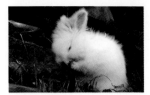

Page 44
Angora rabbit
Canon D30, 28–135mm lens at the
135 end, 550 EX flash

Page 45
Polecat ferret
Canon D30, 28–135mm lens at the
135 end, 550 EX flash

Page 46
Polecat ferret
Canon D30, 28–135mm lens at the
135 end, 550 EX flash

Page 47
English springer spaniel
Canon D30, 28–135mm lens

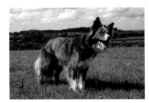

Page 48
Red Border collie
Canon D30, 28–135mm lens

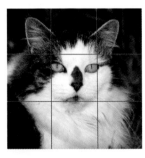

Page 49
Domestic long-haired tabby cat
Canon D30, 28–135mm lens at the
100mm end, 550 EX flash

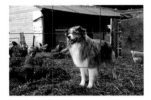

Page 49
Australian shepherd
Canon D30, 28–135mm lens at the
28mm end, 550 EX flash

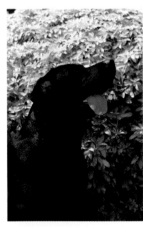

Page 50
Black Labrador retriever
Canon D30, 50mm lens

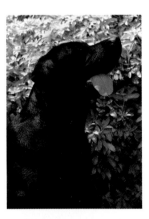

Page 50
Black Labrador retriever
Canon D30, 50mm lens

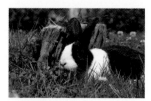

Page 51
Dutch rabbit
Canon D30, 28–135mm lens

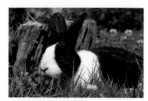

Page 51
Dutch rabbit
Canon D30, 28–135mm lens

Page 52
German short-haired pointer
Canon D30, 28–135mm lens

Page 52
German short-haired pointer
Canon D30, 28–135mm lens

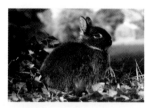

Page 53
Netherland dwarf rabbit
Canon D30, 28–135mm lens, f/5.6

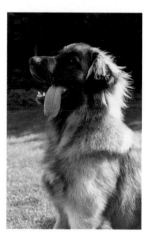

Page 54
Leonberger
Canon D30, 28–135mm lens,
reflector

Page 55
Dutch rabbit
Canon D30, 28–135mm lens, 550
EX fill-in flash

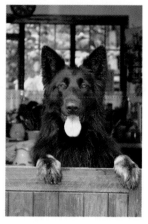

Page 56
German shepherd
Canon D30, 28–135mm lens

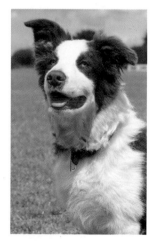

Page 57
Border collie
Canon D30, 28–135mm lens

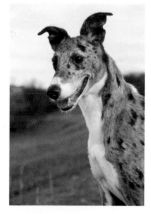

Page 58
Collie x greyhound lurcher
Canon D30, 28–135mm lens

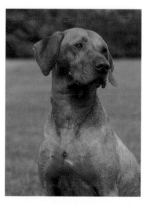

Page 58
Hungarian vizsla
Canon D30, 28–135mm lens

Page 59
Domestic short-haired cat
Canon D30, 28–135mm lens at the
135 end, 550 EX flash

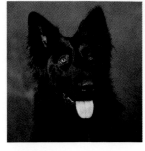

Page 60
Netherland dwarf rabbit
Canon D30, 90mm macro lens, f/2.8

Page 61
Lurcher
Canon D30, 28–135 lens

Page 62
Boxers
Canon D30, 28-135 lens, two
studio flash units

Page 63
German shepherd
Canon D30, 28-135mm lens, two
studio flash units

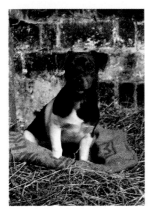

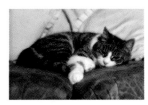

Page 65
Domestic short-haired tabby cat
Canon D30, 28–135mm lens on
camera flash with soft-focus filter

Page 66
Mongrel
Canon D30, 50mm lens, two
studio flash units

Page 67
Persian cat
Canon D30, 28–135mm lens at the
135 end, two studio flash units

Page 64
Jack Russell terrier
Canon D30, 50mm lens, studio
flash units, 1/60sec at f/11

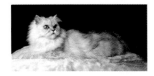

Page 68
Persian cat
Canon D30, 28–135mm lens,
one studio flash unit

Page 69
English springer spaniels
Canon D30, 50mm lens, one studio
flash unit

Page 70
Cross-bred collie
Canon D30, 28–135mm lens at the
28mm end, 550 EX flash

Page 71
Golden retriever
Canon D30, 28–135mm,
550 EX flash

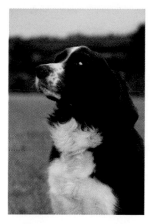

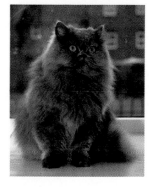

Page 74
Staffordshire bull terrier
Canon D30, 28–135mm lens,
550 EX bounced flash

Page 76
Persian cat
Canon D30, 90mm macro lens.
Single flash unit fired into a white
umbrella

Page 77
Persian cat
Canon D30, 50mm lens, natural
daylight, reflector

Page 72
Cross-bred spaniel
Canon D30, 50mm lens, 550 EX
flash

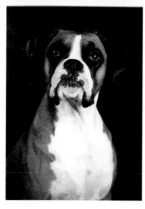

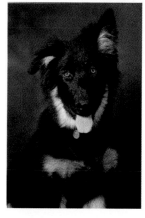

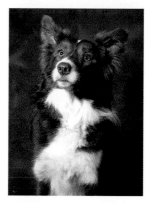

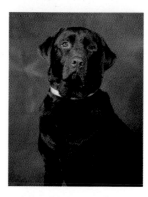

Page 78
Boxer
Canon D30, 90mm lens, two
studio flash units, 1/60sec at f/11

Page 79
German shepherd
Canon D30, 90mm lens,
two studio flash units

Page 79
Red Border collie
Canon D30, 90mm lens,
two studio flash units

Page 80
Chocolate Labrador retriever
Canon D30, 90mm lens, two
studio flash units

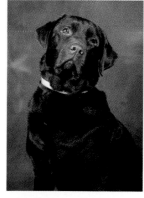

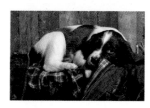

Page 80
Chocolate Labrador retriever
Canon D30, 90mm lens, two
studio flash units

Page 81
English springer spaniel
Canon D30, 28–135mm lens,
studio flashes

Page 82
Golder Labrador retriever
Canon D30, 28–135mm lens,
two studio flash units

Page 82
Golder Labrador retriever
Canon D30, 50mm lens, two
studio flash units

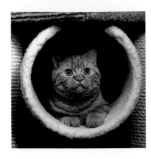

Page 83
*Persian cat
Canon D30, 28–135mm lens,
two studio flash units*

Page 84
*Domestic short-haired cat
Canon D30, 28–135mm lens,
two studio flash units*

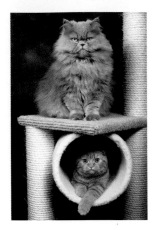

Page 86
*Persian cat and domestic
short-haired cat
Canon D30, 28–135mm lens,
two studio flash units*

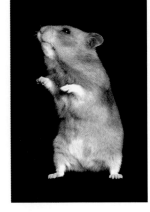

Page 87
*Golden hamster
Canon D30, 90mm lens,
one studio flash unit*

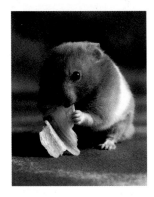

Page 88
*Hamster
Canon D30, 90mm lens,
550 EX flash*

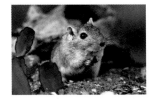

Page 89
*Gerbil
Canon D30, 90mm lens,
550 EX flash off-camera*

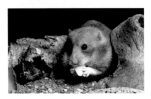

Page 91
*Golden hamster
Canon D30, 90mm lens,
one studio flash unit*

Page 93
*Gerbil
Canon D30, 90mm lens,
550 EX flash off-camera*

Page 94
*Golden hamster
Canon D30, 90mm lens,
one studio flash*

Page 95
*Gerbil
Canon D30, 90mm lens,
550 EX flash off camera*

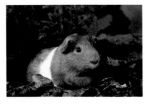

Page 97
*Short-haired guinea pig
Canon D30, 28–135mm lens at
35mm, 550 EX flash off-camera*

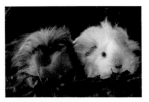

Page 97
*Long-haired guinea pigs
Canon D30, 28–135mm lens at
35mm, 550 EX flash off-camera*

Page 98
English rabbit
Canon D30, 28–135mm lens,
550 EX flash off-camera

Page 98
English rabbit
Canon D30, 90mm lens,
550 EX flash off-camera

Page 99
Albino ferret
Canon D30, 28–135mm lens,
550 EX flash off-camera

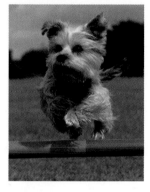

Page 100
Yorkshire terrier
Canon D30, 28-135mm lens,
550 EX flash

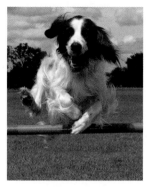

Page 101
Red and white setter
Canon D30, 28–135mm lens,
550 EX flash

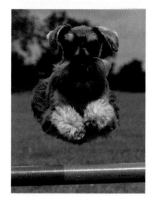

Page 101
Miniature schnauzer
Canon D30, 28–135mm lens,
550 EX flash

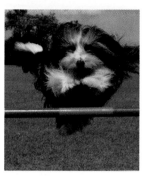

Page 101
Bearded collie
Canon D30, 28–135mm lens,
550 EX flash

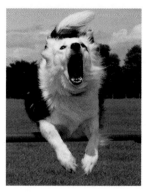

Page 101
Border collie
Canon D30, 28–135mm lens,
550 EX flash

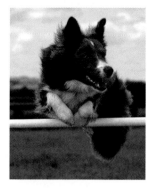

Page 102
Red Border collie
Canon D30, 90mm lens,
1/750sec at f/5.6

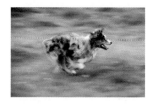

Page 103
Australian shepherd
Canon D30, 28–135mm lens, 1/60sec

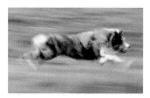

Page 104
Australian shepherd
Canon D30, 28–135mm lens, 1/15sec

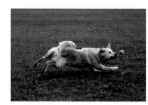

Page 106
Golden retriever
Canon D30, 28–135mm lens,
1/1000sec

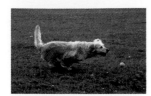

Page 106
Golden retriever
Canon D30, 28–135mm lens,
1/1000sec

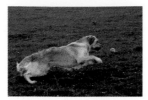

Page 107
Golden retriever
Canon D30, 28–135mm lens,
1/1000sec

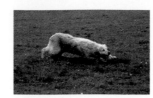

Page 107
Golden retriever
Canon D30, 28–135mm lens,
1/1000sec

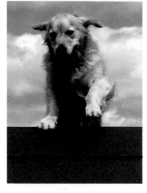

Page 108
Golden retriever
Canon D30, 90mm lens, 1/750sec

Page 109
Boxer
Canon D30, 90mm lens, 1/750sec

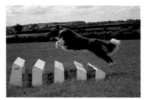

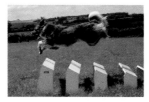

Page 110
Red Border collie
Canon D30, 28–135mm lens,
1/1000sec

Page 111
Red Border collie
Canon D30, 28–135mm lens,
1/1000sec

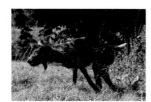

Page 112
Bracco Italiano
Canon D30, 28–135mm lens

Page 112
German wire-haired pointer
Canon D30, 28–135mm lens

Page 113
German wire-haired pointer
Canon D30, 28–135mm, 1/60sec

Page 114
German wire-haired pointer
Canon D30, 28–135mm lens at the
135 end, 1/1000sec

Page 114
German wire-haired pointer
Canon D30, 28–135mm lens at the
135 end 1/1000sec

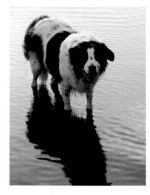

Page 115
Border collie
Canon D30, 28–135mm,
550 EX flash

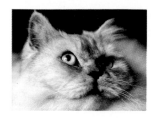

Page 116
Persian cat
Canon D30, 90mm lens. Image
manipulation in Adobe Photoshop 6.0

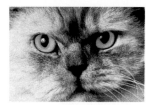

Page 118
Persian cat
Original image Canon D30, 90mm
lens, studio flash units. Adobe
Photoshop 6.0 was used to create
the final picture

Page 122
Bracco Italiano
Canon D30, 90mm lens. Image
manipulation in Adobe Photoshop 6.0

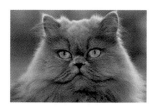

Page 123
Persian cat
Canon D30, 90mm lens, 550 EX
flash, diffuser

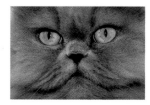

Page 123
Persian cat
Canon D30, 90mm lens, 550 EX
flash, diffuser. Image manipulation
in Adobe Photoshop 6.0

Page 124
Munsterlander
Canon D30, 28–135mm lens

Page 124
Munsterlander
Canon D30, 28–135mm lens. Image
manipulation in Adobe Photoshop 6.0

Page 125
Canon D30, 28–135mm lens.
Image manipulation in
Adobe Photoshop 6.0

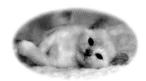

Page 126
Burmese kitten
Canon D30, 50mm lens. Image
manipulation in Adobe Photoshop 6.0

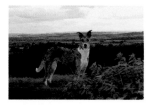

Page 127
Collie x greyhound lurcher
Canon D30, 28–135mm lens, 550
EX flash. Tone changes in Adobe
Photoshop 6.0

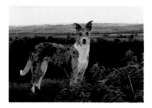

Page 127
Collie x greyhound lurcher
Canon D30, 28–135mm lens, 550
EX flash. Tone changes in Adobe
Photoshop 6.0

Page 129
Yorkshire terrier
Canon D30, 50mm lens. Image
manipulation in Adobe Photoshop 6.0

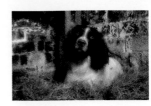

Page 130
English springer spaniel
Canon D30, 50mm lens, two studio
flash units. Image manipulation in
Adobe Photoshop 6.0

Page 128
Black Labrador retrievers
Canon D30, 28–135mm lens.
Image manipulation in
Adobe Photoshop 6.0

Page 130
Domestic short-haired tabby cat
Canon D30, 50mm lens, two studio
flash units. Image manipulation in
Adobe Photoshop 6.0

Index

UPHOLSTERY

TOYMAKING

DOLLS' HOUSES AND MINIATURES

CRAFTS

GARDENING